MW00772628

The Pirelli Calendar

Universe

Design: Damiano Viscardi

Translation: Studio Queens

Cover: Dawn Bossman, Elizabeth Smith

First published in the United States of America in 2001
by UNIVERSE PUBLISHING
A Division of Rizzoli International Publications, Inc.
300 Park Avenue South
New York, NY 10010

2001 2002 2003 2004 2005 / 10 9 8 7 6 5 4 3 2 1

Printed and bound in Italy

Library of Congress Control Number: 2001094246
ISBN 0-7893-0658-1

Contents

Introduction

It all started in the Sixties. The English Sixties, when rock was starting to become all the rage, when swinging London was the groovy place to be for lovers of visual arts—photography and movies.

Derek Forsythe was no exception. A bright young Londoner, well acquainted with trendy photographers, he landed his first job in the marketing department of the English Pirelli after finishing his studies. The post did not really seem to fit the photographer's creative urge, which had little in common with the needs of an industrial group, which produced and marketed tires. But in those years of transition such an odd mix was bound to produce surprising results. It worked out for the young Londoner, who was lucky to work for a company "enlightened" enough to sense his hidden potential. So when in the middle of 1963, after just a year in the company, he told his boss about an idea of his, he found no closed doors. The idea was actually welcomed. It was, in fact, a tempting concept. The year before, a pin up calendar was published aimed at tire centers: why not replace it with the sophisticated work of a brilliant talent from London's miscellaneous world of visual arts? The subject was a classic theme: female beauty. Forsythe's boss at the English branch thought about it for a minute and, after briefly calling Milan, okayed the proposal. The young marketing man flew to the Balearic Islands with photographer Robert Freeman. Two weeks later, the twelve photographs of the 1964 calendar were ready to go to press. The Pirelli calendar was born.

At the time, art productions of all sorts were plentiful, and the calendar probably went relatively unnoticed in its first year, unsupported by the media launches and

promotional events later introduced. But over the next two years, the calendar, with its simple and liberal pictures, was already bearing precious witness to contemporary times. People were talking about it. Some of the few copies printed were mailed to glamorous addresses such as John Lennon's place and Buckingham Palace, where the calendar was sent to Prince Philip of Edinburgh.

So when in 1967 the calendar was not published—for reasons unknown to history and unrecorded by company files—many people noticed its absence. And many made themselves heard: complaints got so intense that in 1968 the special issue came out again, followed the next year by a version of the calendar which is to be remembered among the most daring ones thanks to the images "captured" by Harry Peccinotti on the West Coast, a venue much celebrated by major movies and books published in those years, from *Blood and Strawberries* to *Zabriskie Point*. The calendar thus confirmed its function as a reliable witness to the hectic post-1968 years. This role was reinforced in the following years, when the calendar was entrusted to the best photographers of this cultural *milieu*, from Sarah Moon—the first woman to get an assignment, and the first person to show a naked breast—to Hans Feurer, who broke a long phase of creative inactivity with the calendar.

The 1974 calendar marked the passing of a decade and coincided with much changed times, from the creative drive of the Beatles to the sinister years of terrorism. Those were dark times, worsened by the oil crisis and the many uncertainties of a world suddenly confronted with the problems of much-contested resolution. Those were not calendar years and in 1975 the Pirelli one ceased to be print-

ed. In its absence it remained the object of discussion, an indication of the new climate and an impossible presence in the restless years of such a profound crisis.

A decade was to pass before it reappeared in 1984 when the conditions were right for its rebirth. It was produced by the British Pirelli once again, which brought in a new art director. Martin Walsh was a middle-aged gentleman resident in Switzerland where he lived off the earnings from the many ads invented as a leading creative force in one of the world's major advertising agencies. From 1984 on the Pirelli calendar became his principal task and he produced a display of ideas without precedent. The 1987 calendar presented black women for the first time with a slightly immature sixteen-year-old, unknown to the fashion catwalks, a certain Naomi Campbell; the Olympics calendar came in 1989, a very non-olympic year; the ballet calendar (1988) featured an anomalous male presence. One of the factors that made the gift increasingly special was the introduction of the tire tread theme in the form of a discreet sign, hidden in the photos. It was like a hidden mention, similar to Alfred Hitchcock's habit of appearing in one frame of his films, with the spectator having to identify him. The same applied to the Pirelli tread marks that were turned into jewels (1987), fabric patterns (1985) and decorative banners (1992).

The Martin Walsh era continued for approximately a decade. Then Pirelli decided to bring the art direction of its calendar into the company. This was in the early Nineties and it had just come through a major crisis marked by a reorganization that jolted it from top to bottom. The Milan Company was then ready for a relaunch. This also affected the calendar which set off in 1994 along a new path under the guidance of the communications management of the group's leading company, which entrusted its creation to the best photographers—from Richard

Avedon to Peter Lindbergh, Annie Liebovitz, Herb Ritts and Mario Testino and Bruce Weber, all the great names of photography went through the 'Cal' experience as it had now become known in English slang. The photographers may have been protagonists but so were the models, chosen not from the famous names of the catwalks but from those who had yet to make it—from a very young Kate Moss (1994) and Christie Turlington (1995) to Laetitia Casta, the star of the 1999 calendar photographed by Bruce Weber and the 2000 one by Annie Liebovitz. With this formula the calendar established itself as a cult object of the end of the millennium. It was an object of desire that everyone wanted and hardly anyone had. The world press started to talk about months in advance, trying to gain information on the set to pass on to its readers. In the meantime—further proof of its now recognized artistic value—the photographs started an international tour that has taken them to the world's leading museums: from Palazzo Grassi in Venice to the Carrousel du Louvre in Paris and the MASP in Sao Paolo. This itinerant exhibition designed by Gae Aulenti has visited ten countries on three continents and is about to arrive in Japan. Who knows whether, on that day in 1963, the enlightened manager who approved the project of his young employee with a passion for photography could ever have imagined all this...

Pirelli 2001 Calendar

photographed by Mario Testino

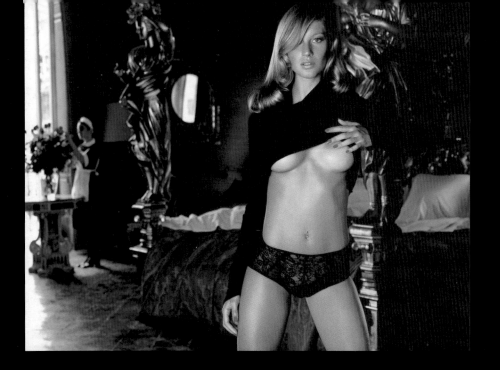

2001 – JANUARY

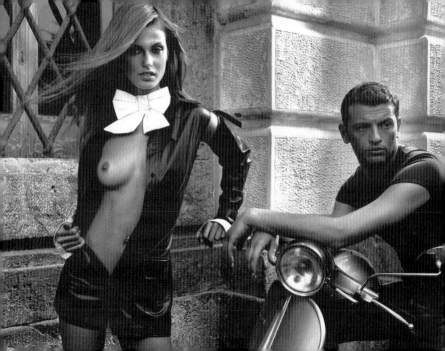

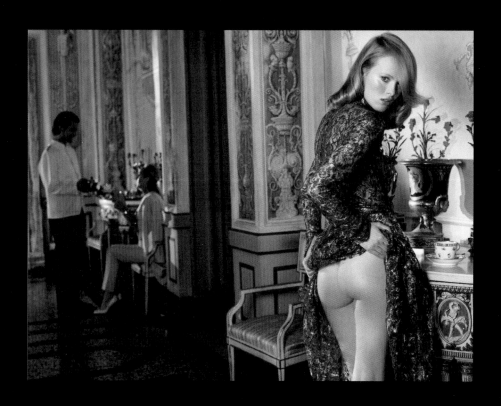

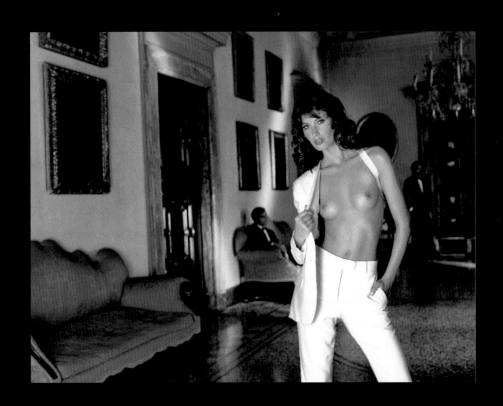

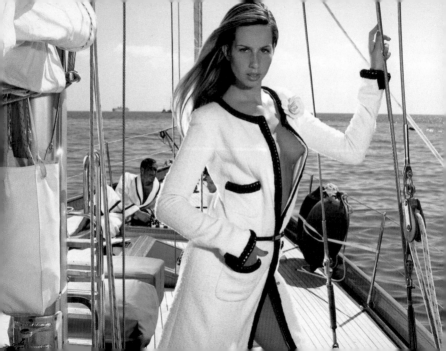

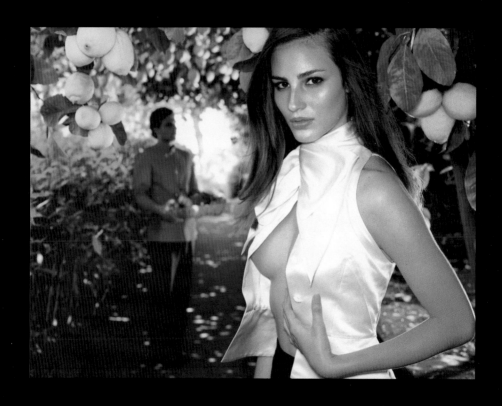

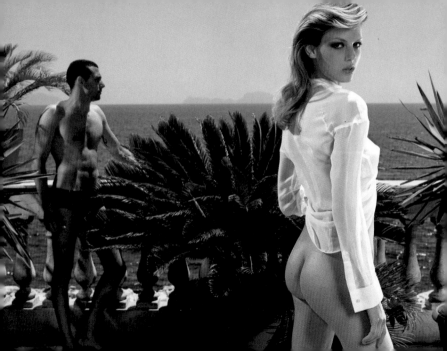

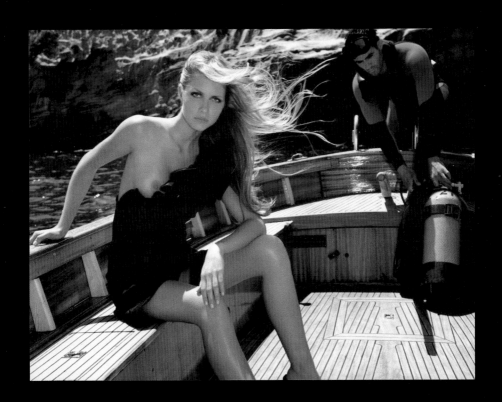

2001 – AUGUST

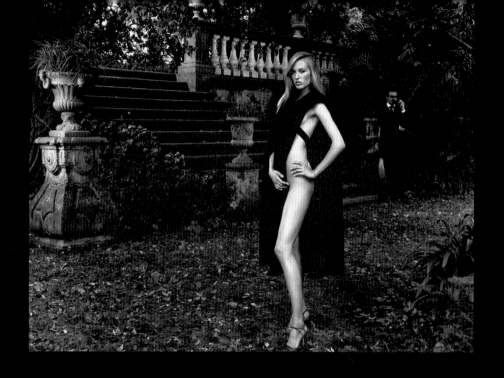

2001 – SEPTEMBER

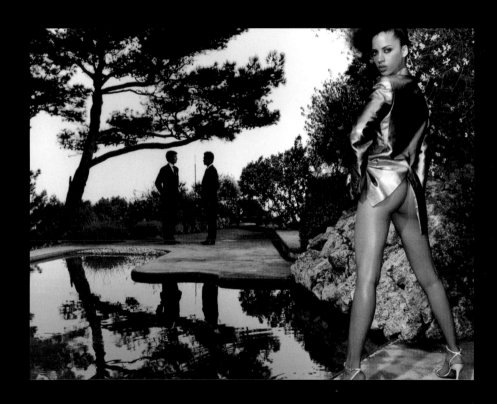

2001 – OCTOBER

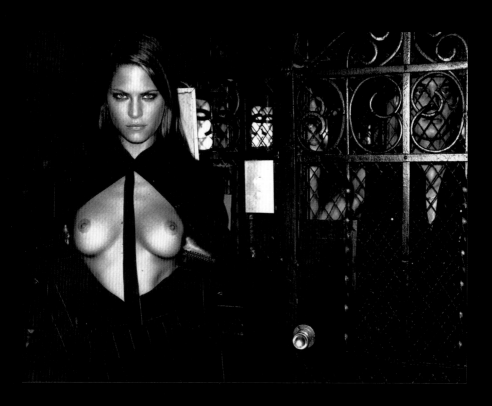

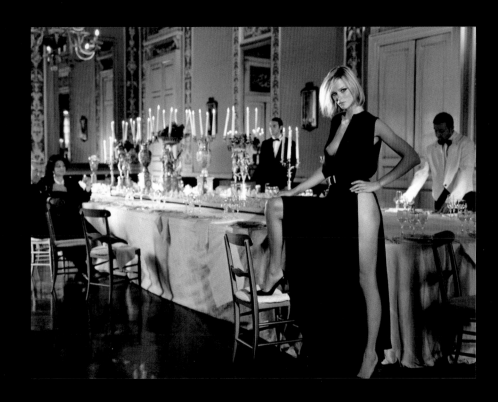

The Pirelli Calendar 1964–2000

1964
Robert Freeman

There was no grand launch,
no public relations effort,
and no response from the
newspapers.
What did happen, though,
was that Pirelli began
to get letters from dealers;
for some reason Pirelli, after
the calendar, was suddenly
popular.

MICHAEL PYE, *THE PIRELLI CALENDAR ALBUM*, 1988

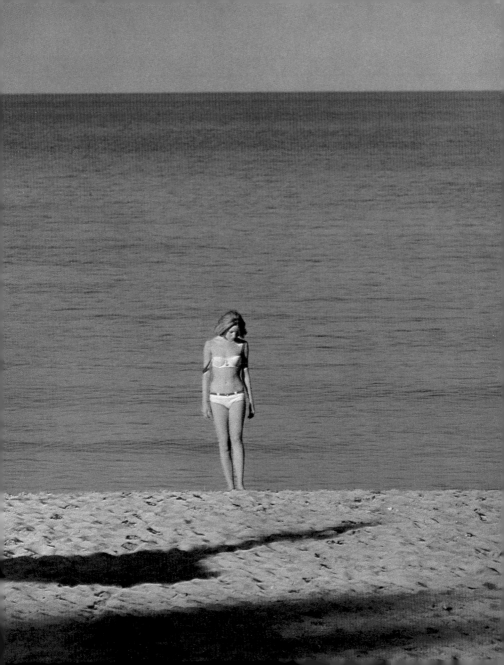

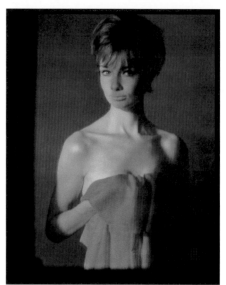

1964 – FEBRUARY

1964 – MARCH

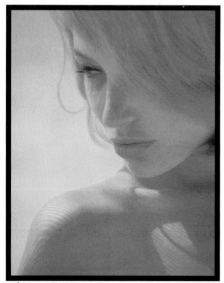

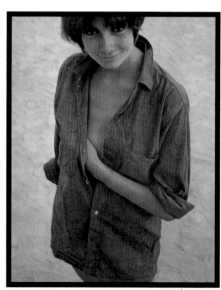

1964 – APRIL

1964 – MAY

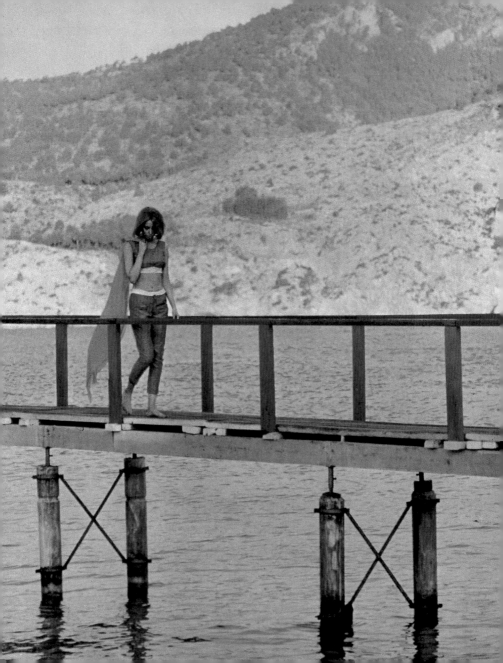

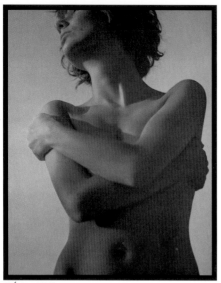

1964 – JULY

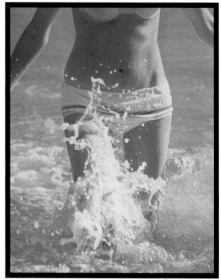

1964 – AUGUST

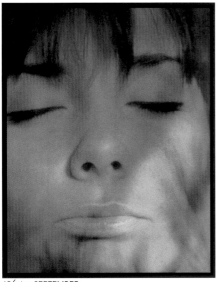

1964 – SEPTEMBER

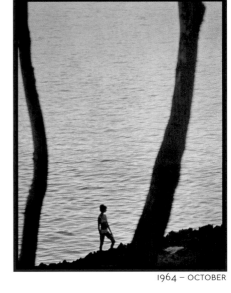

1964 – OCTOBER

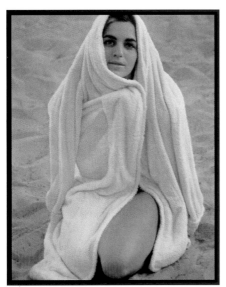

1964 – NOVEMBER

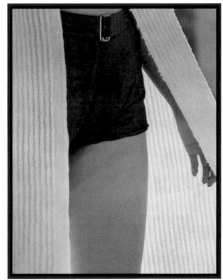

1964 – DECEMBER

1965
Brian Duffy

The 1965 Calendar presents
an image of a girl who is the
symbol of a new era.
A beautiful girl dressed in
the same way as her
contemporaries, the same
as many that could be seen
in those times in the streets
of Paris, London or Milan,
sitting at a table in a café and
smoking. A girl alone, a girl
who would look a man in the
eyes and assess him before
choosing.

GIAMPIERO MUGHINI, *PANORAMA*, JANUARY, 24TH, 1997

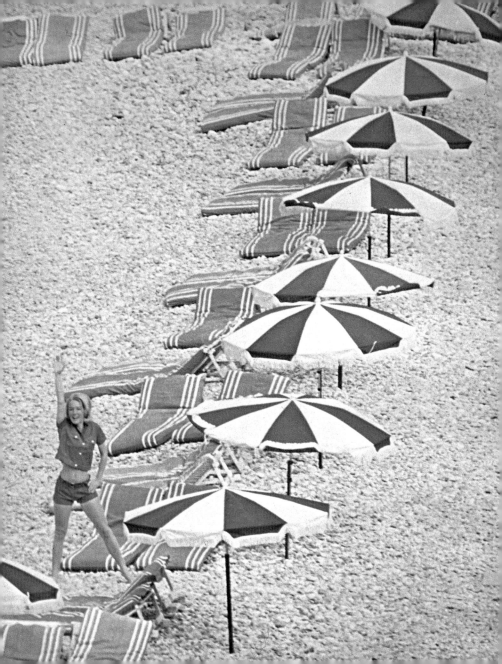

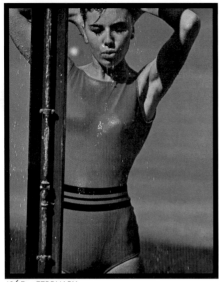

1965 – FEBRUARY

1965 – MARCH

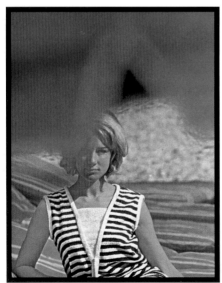

1965 – MAY

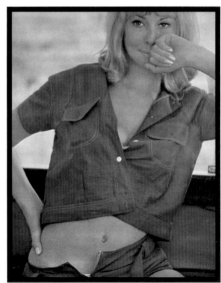

1965 – JUNE

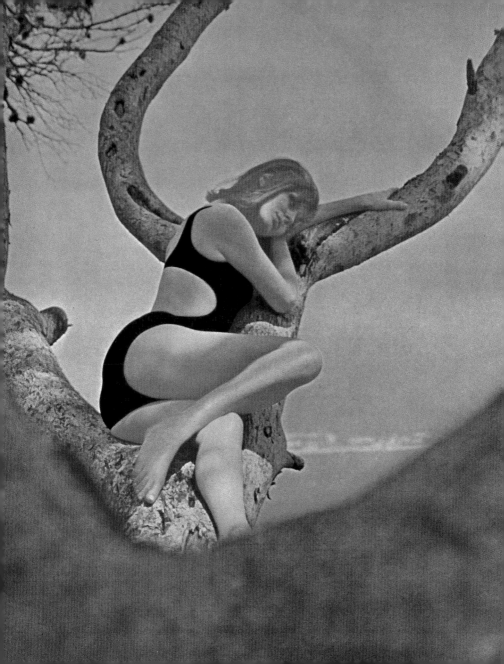

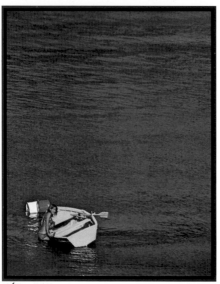

1965 – JULY

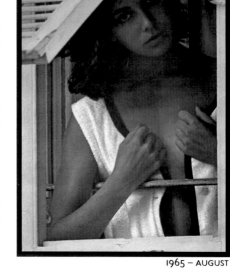

1965 – AUGUST

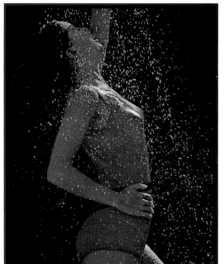

1965 – SEPTEMBER

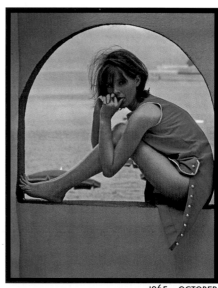

1965 – OCTOBER

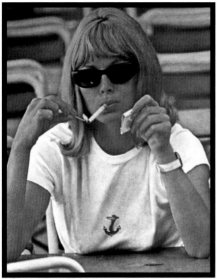

1965 – NOVEMBER

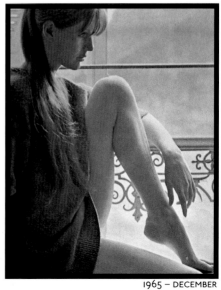

1965 – DECEMBER

1966
Peter Knapp

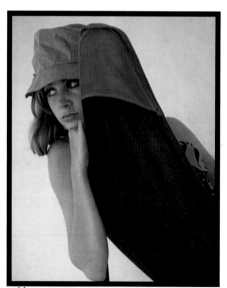

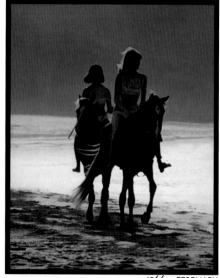

1966 – JANUARY

1966 – FEBRUARY

"What we did in the calendar was already the limit of what you could do then and the models were careful."

PETER KNAPP

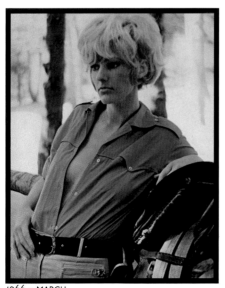

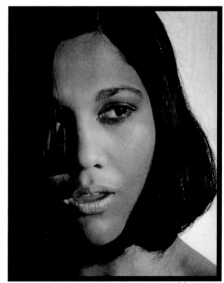

1966 – MARCH

1966 – APRIL

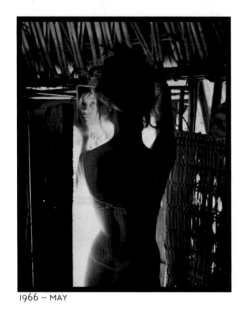

1966 – MAY

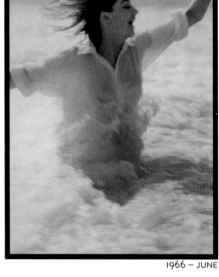

1966 – JUNE

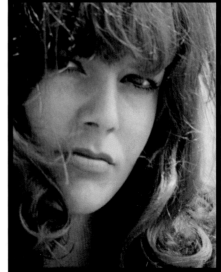

1966 – AUGUST

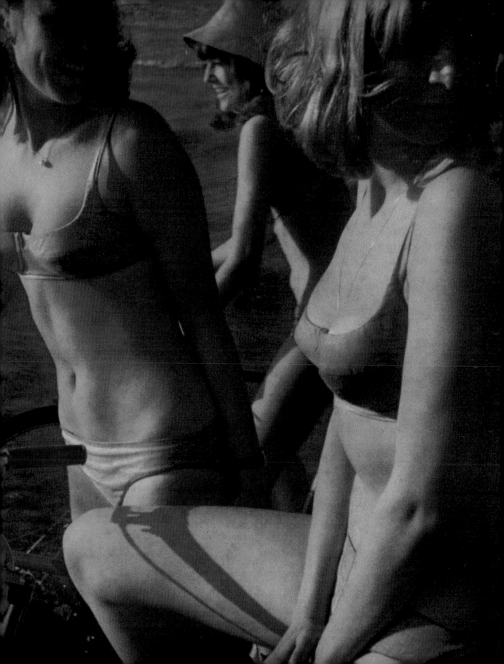

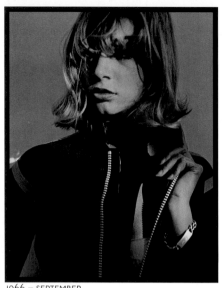

1966 — SEPTEMBER

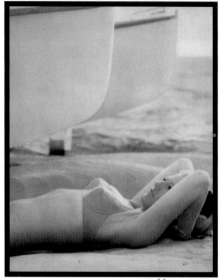

1966 — OCTOBER

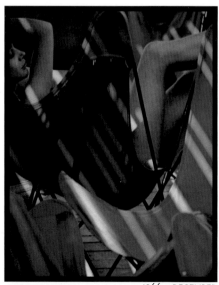

1966 — DECEMBER

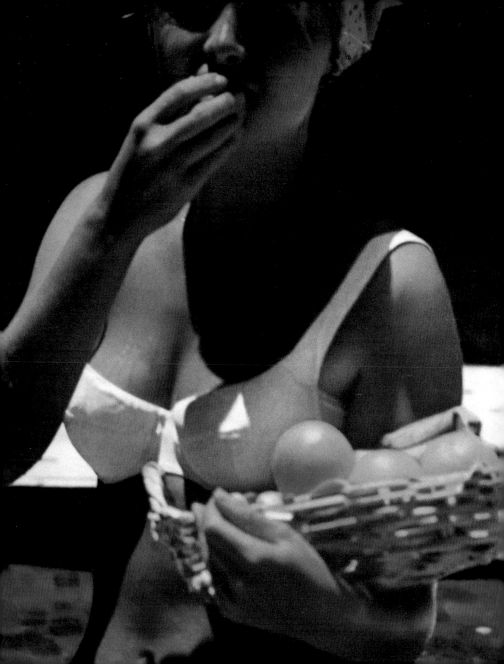

1968
Harri Peccinotti

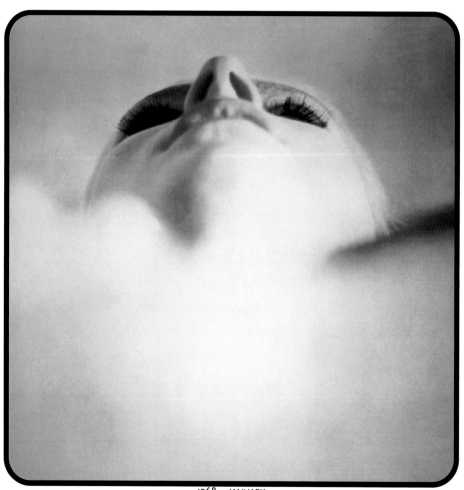

1968 – JANUARY

It is an open question
whether many read poems,
but they were piled high
in basement bookstores...
The calendar team found
poems about love...
and found girls to match
the words...

MICHAEL PYE, *THE PIRELLI CALENDAR ALBUM*, 1988

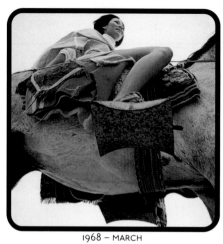

1968 – MARCH

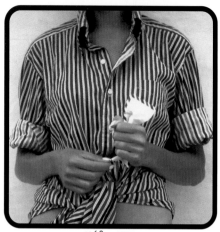

1968 – APRIL

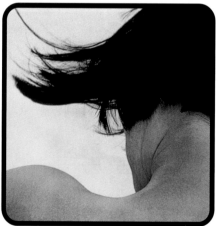

1968 – FEBRUARY

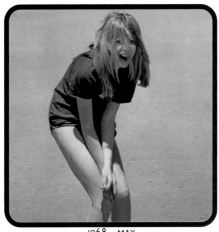

1968 – MAY

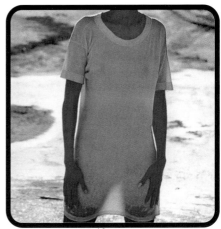

1968 – JUNE

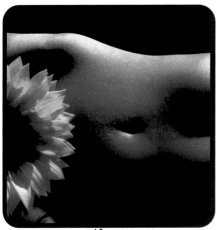

1968 – JULY

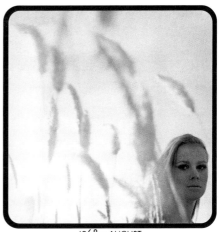

1968 – AUGUST

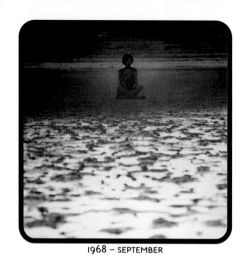

1968 – SEPTEMBER

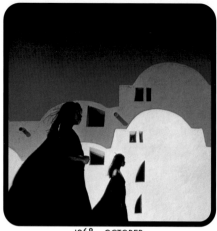

1968 – OCTOBER

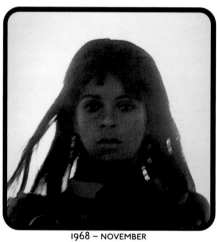

1968 – NOVEMBER

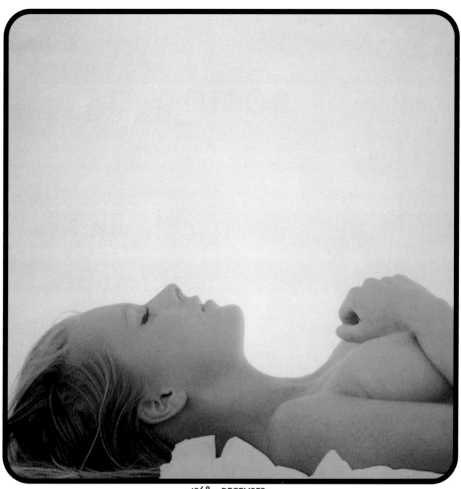

1968 – DECEMBER

1969
Harri Peccinotti

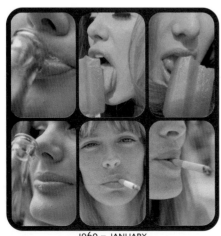

1969 – JANUARY

1969 – FEBRUARY

"Everywhere you turned on the beach there were incredible looking girls, just very sexy girls and they were doing whatever they felt like... I said we wouldn't have to take models or anything; we'd just go and photograph people having a good time in the sun."

HARRI PECCINOTTI

1969 – MARCH

1969 – APRIL

1969 – MAY/COVER

1969 – JUNE

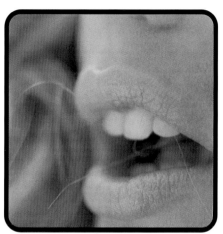

1969 – JULY

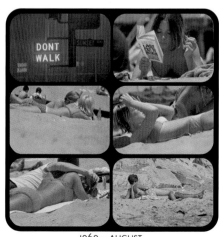

1969 – AUGUST

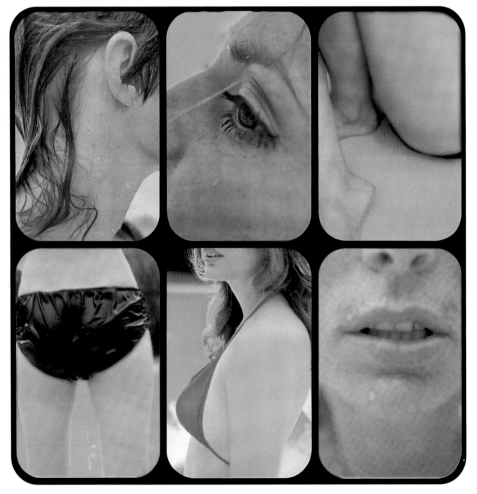

1969 — SEPTEMBER

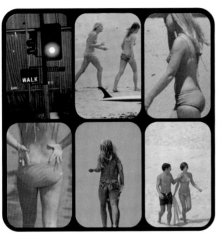

1969 – OCTOBER

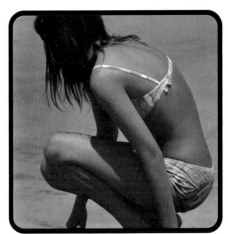

1969 – NOVEMBER

1969 – DECEMBER

1970
Francis Giacobetti

Giacobetti always planned
to dramatize sea and sky,
sometimes setting a tiny girl
against a tumult of clouds
and a sparkle of water;
everything was shot on a
very wide angle lens, and
through special filters which
he had devised.

MICHAEL PYE, *PIRELLI CLASSICS*, 1994

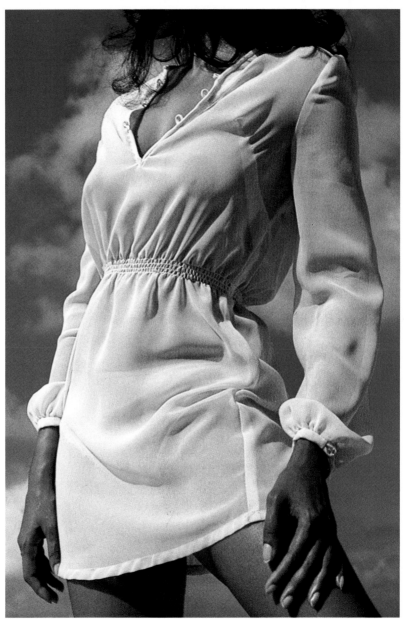

1970 – JANUARY

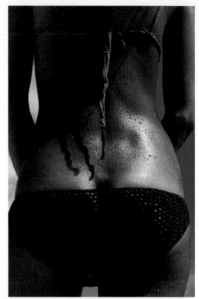

1970 – FEBRUARY

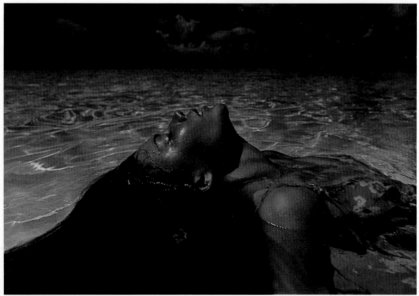

1970 – MARCH

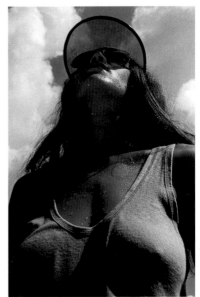

1970 – APRIL

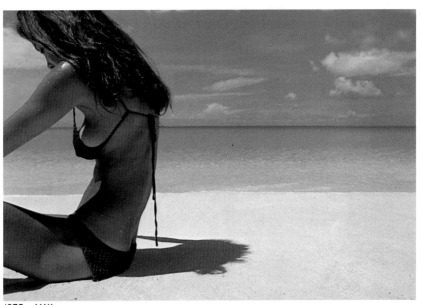

1970 – MAY

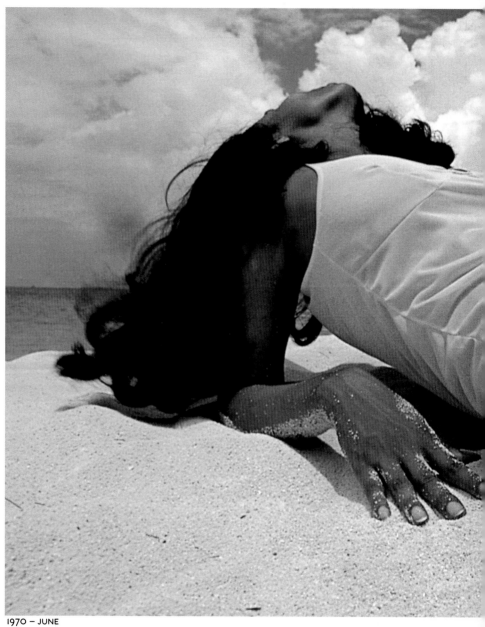

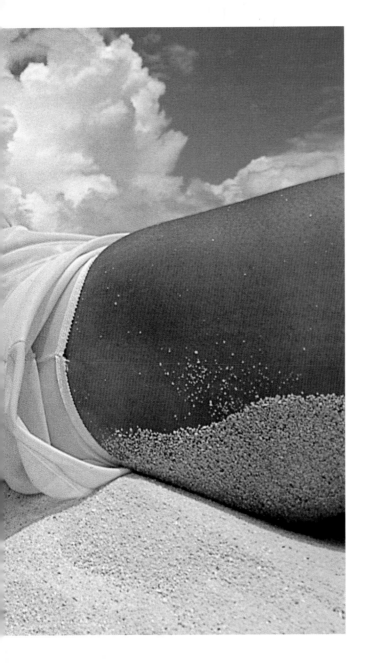

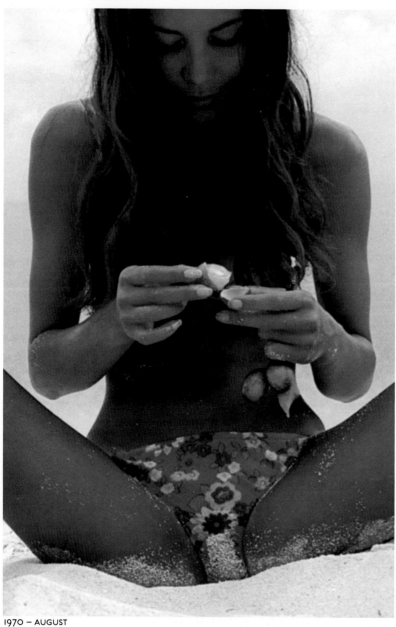

1970 – AUGUST

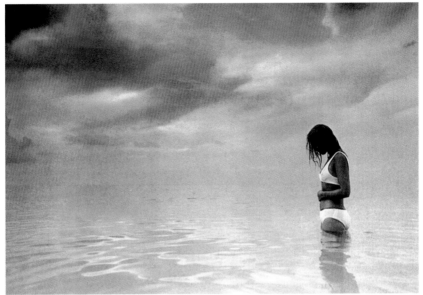

1970 – JULY

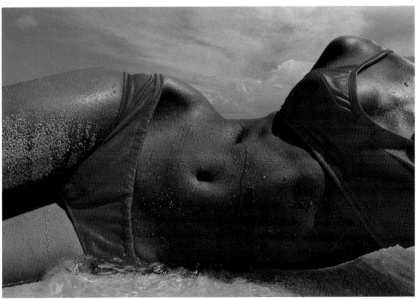

1970 – SEPTEMBER

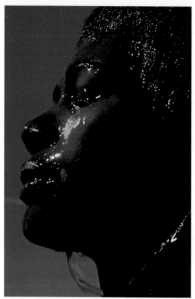

1970 – OCTOBER

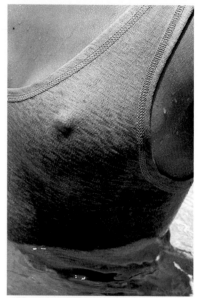

1970 – NOVEMBER

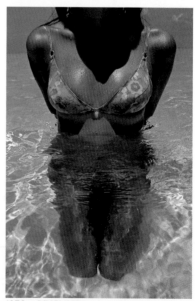

1970 – DECEMBER

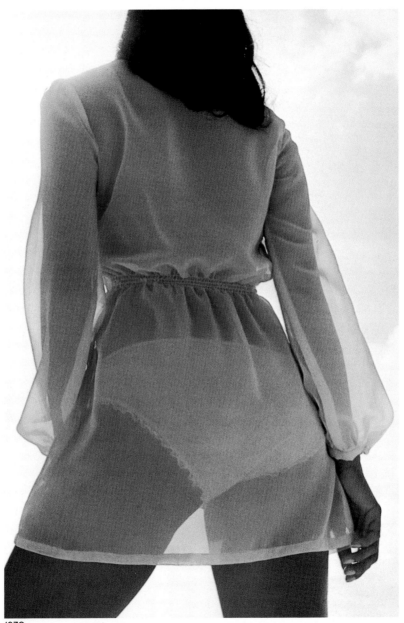

1970

1971 Francis Giacobetti

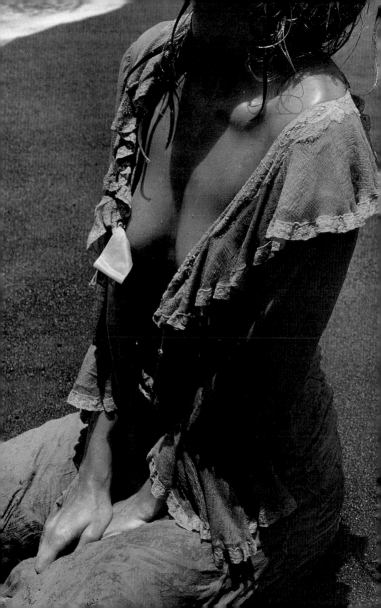

In the 1971 calendar...
Giacobetti pursued the
romantic soft-focus,
moonlit tones; here and
there some garage mechanic
probably felt shortchanged,
given the screaming nudity
offered by the "specialist"
press. By this time the
advertising message of the
calendar was canvassing the
four-thousand-odd lucky
recipients..., not to mention
those not on the list who
tried to procure it through
auction.

GUIDO VERGANI, *THE PIRELLI CALENDAR 1964–1998*, 1998

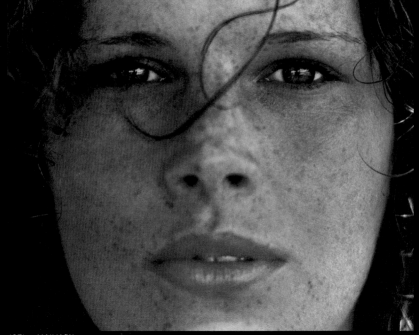

1971 – JANUARY

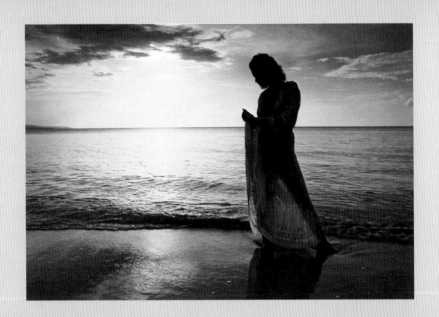

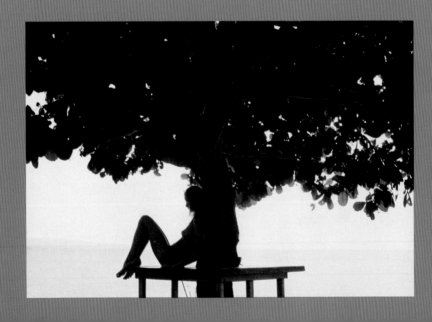

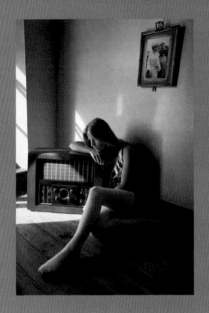

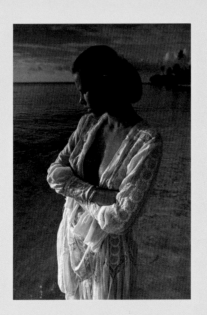

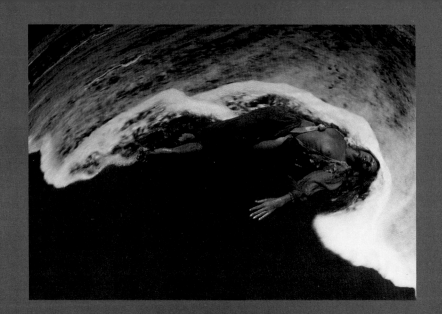

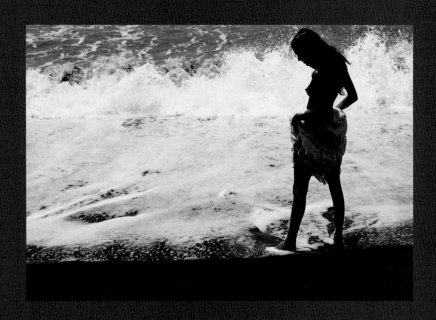

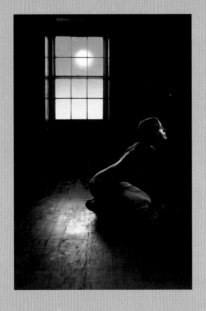

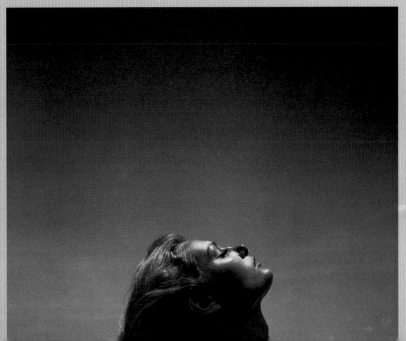

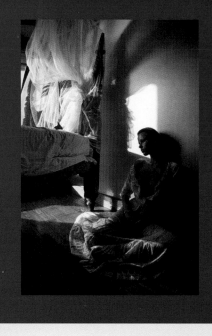

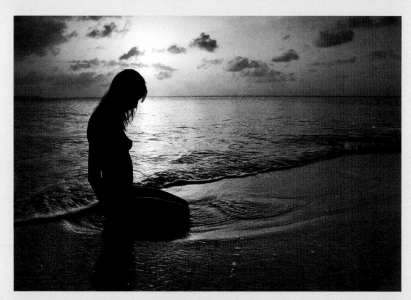

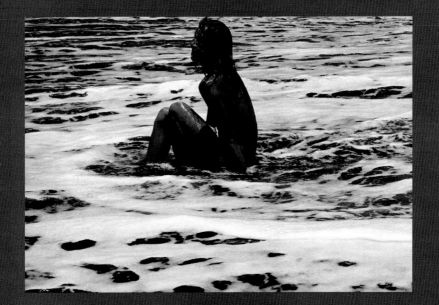

1972
Sarah Moon

In an impressionist climate, lenses reveal a pair of naked breasts for the first time.

SÉRGIO BEREZOVSKY, *VIP*, SEPTEMBER 1997

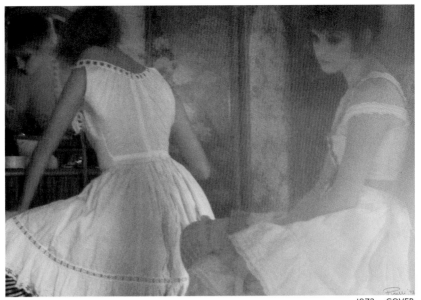

1972 – COVER

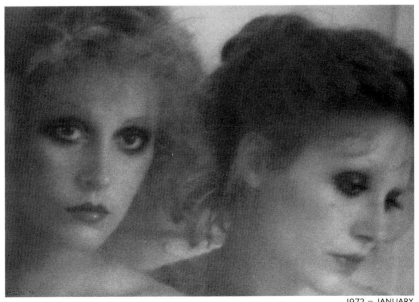

1972 – JANUARY

1972 – FEBRUARY

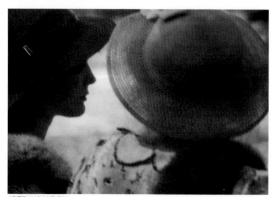

1972 – MARCH

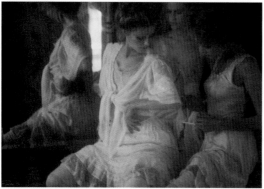

1972 – APRIL

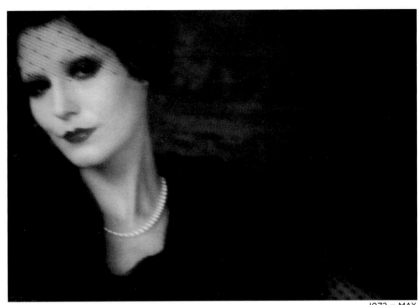

1972 – MAY

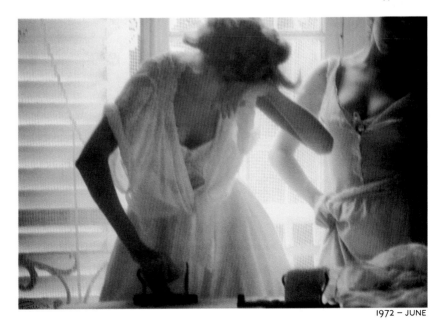

1972 – JUNE

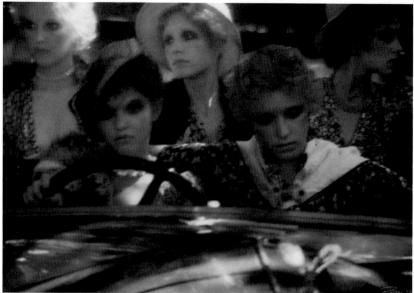

1972 — JULY

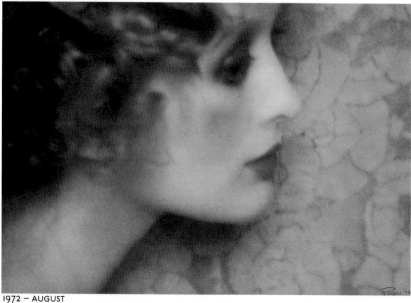

1972 — AUGUST

1972 — SEPTEMBER

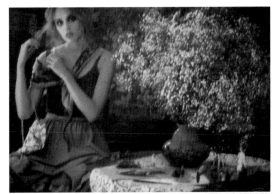

1972 — OCTOBER

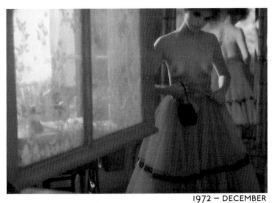

1972 — DECEMBER

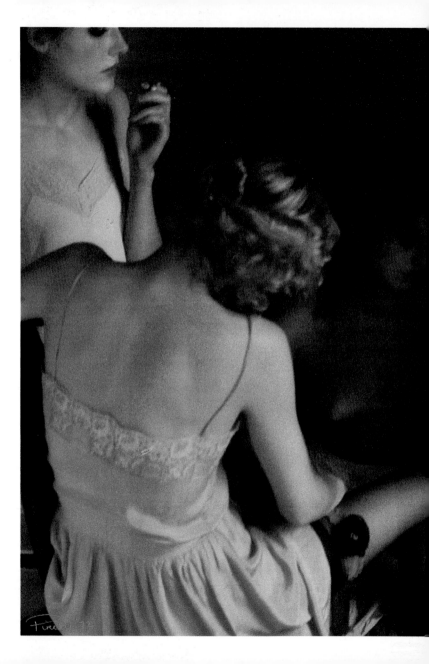

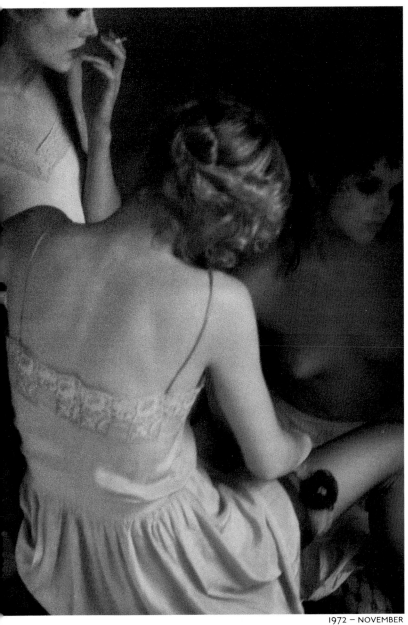

1973
Allen Jones

But it was clothing that
caused a furore in 1973. Pop
painter Allen Jones clad the
models in fetish gear. Parts
of the prints were airbrushed
in imitation of these paintings,
so that real faces and bodies
marged into fictional ones;
the women became
imprisoned in the illusions.

SARAH KENT, *TIME OUT*, MARCH, 26TH, 1997

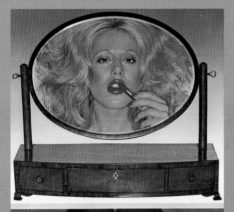

1973 – JANUARY

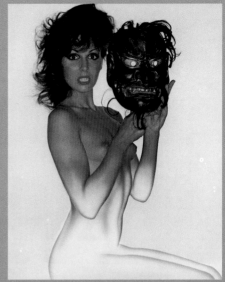

1973 – FEBRUARY

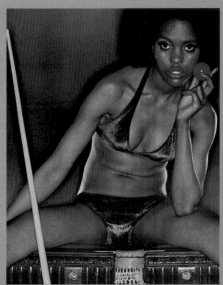

1973 – MARCH

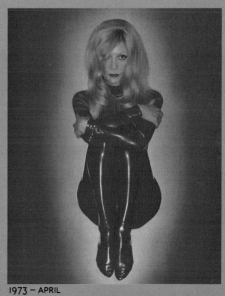

1973 – APRIL

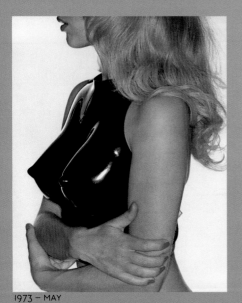

1973 – MAY

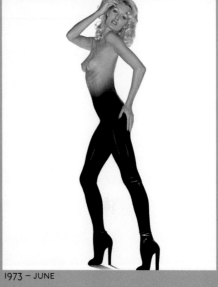

1973 – JUNE

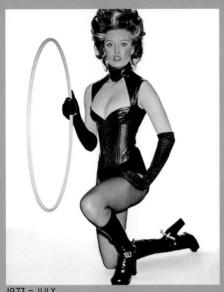

1973 – JULY

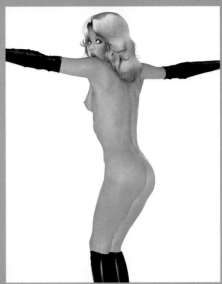

1973 – AUGUST

1973 – SEPTEMBER

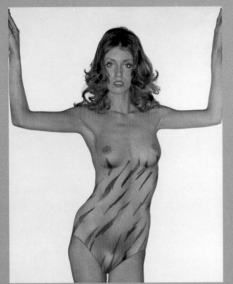

1973 – OCTOBER

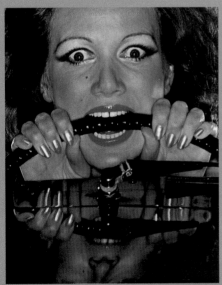

1973 – NOVEMBER

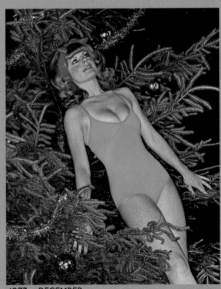

1973 – DECEMBER

1974
Hans Feurer

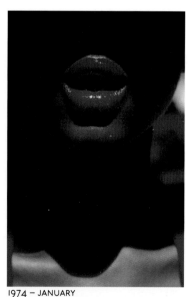

1974 – JANUARY

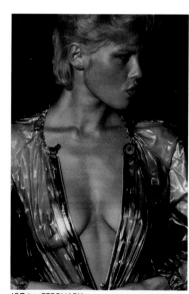

1974 – FEBRUARY

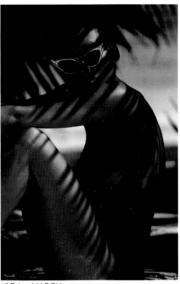

1974 – MARCH

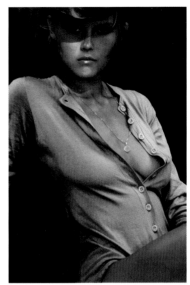

1974 – APRIL

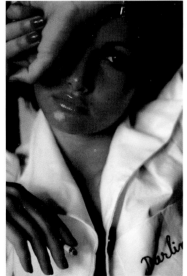

1974 – MAY

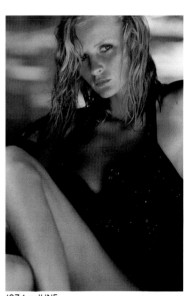

1974 – JUNE

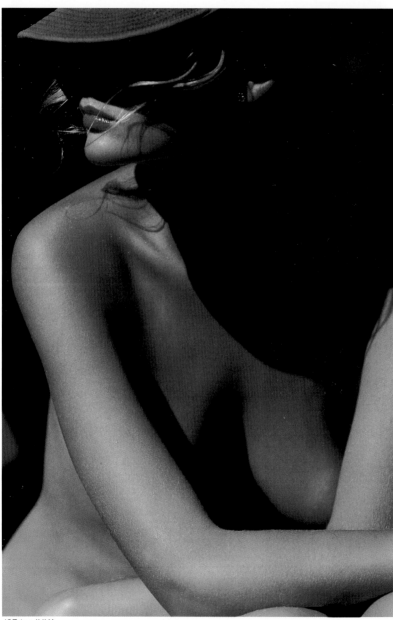

1974 – JULY

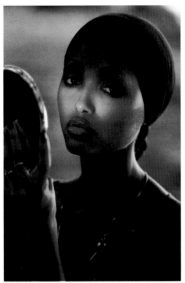

1974 – AUGUST

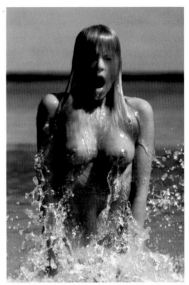

1974 – SEPTEMBER

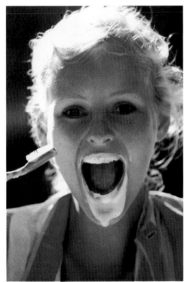

1974 – OCTOBER

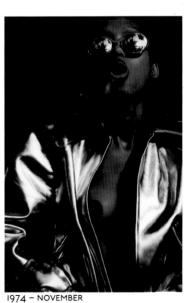

1974 – NOVEMBER

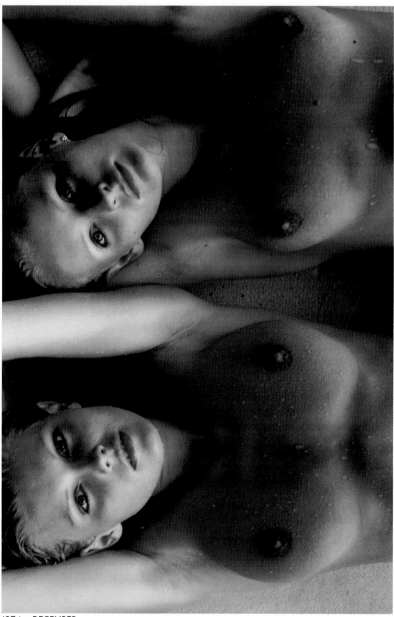

1974 – DECEMBER

There'll be an empty space
in the boardroom wall
next year: after ten years
of imposing stylish sex,
Pirelli have decided to stop
production of the most
prestigious calendar.

COLIN DUNNE, *DAILY MIRROR*, MARCH, 28TH, 1974

1984
Uwe Ommer

The symbol of swinging
London's best years
returns—triumphant as
a ship in a victorious fleet,
as warm as the South Sea
sands, as sensual as a
Polynesian tamuré—it's the
Pirelli calendar.

STEFANO ARCHETTI, *L'EUROPEO*, NOVEMBER, 26TH, 1983

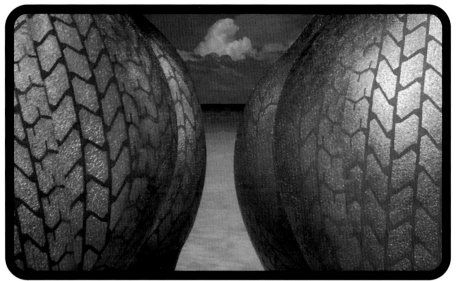

1984 – COVER

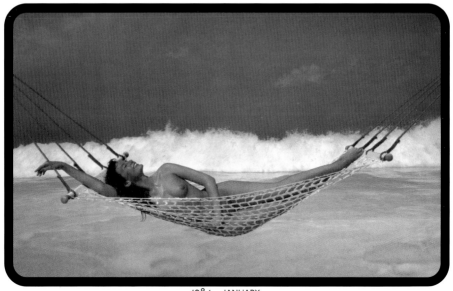

1984 – JANUARY

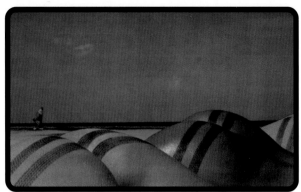

1984 – FEBRUARY

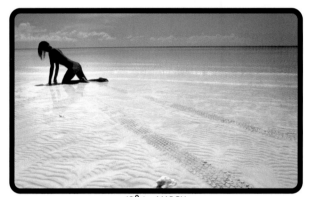

1984 – MARCH

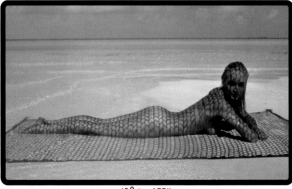

1984 – APRIL

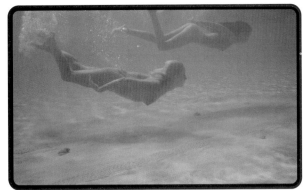

1984 – MAY

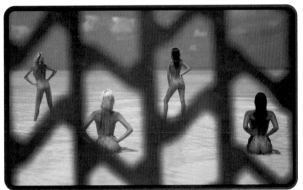

1984 – JUNE

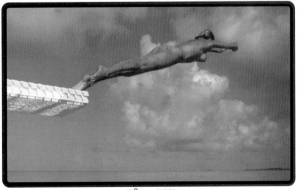

1984 – JULY

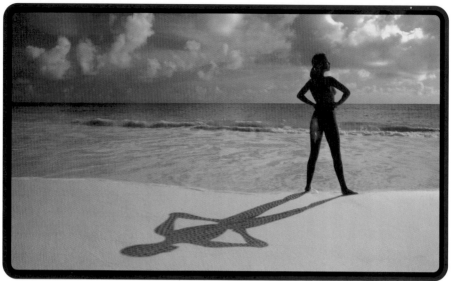

1984 – AUGUST

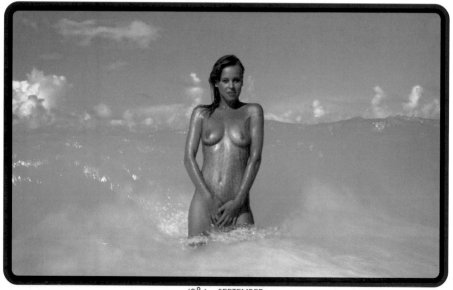

1984 – SEPTEMBER

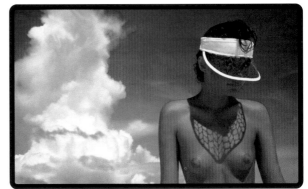

1984 – OCTOBER

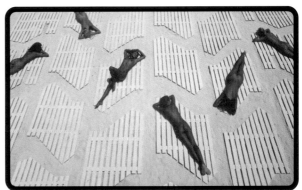

1984 – NOVEMBER

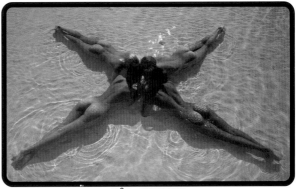

1984 – DECEMBER

1985
Norman Parkinson

Now, some time later, after
having scrutinized the two
Riace bronze statues from all
angles and concluded that
there was nothing more
beautiful than the male form,
I confess I've changed my
mind because there's really
nothing more beautiful than
live women, some being
even more beautiful in
photographs; in fact, they are
perfect only in photographs.

GIORGIO SOAVI, *EPOCA*, SUPPLEMENT, DECEMBER 1984

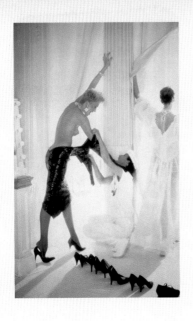

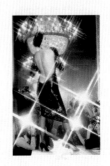

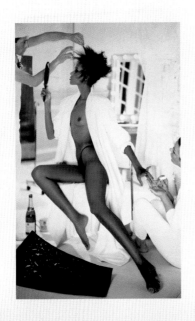

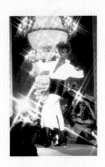

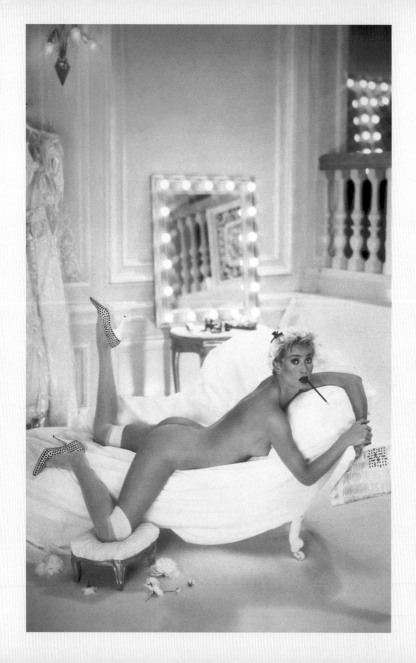

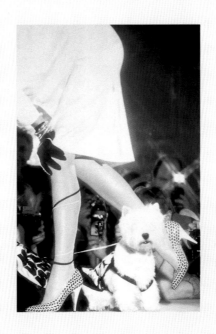

1985 – APRIL

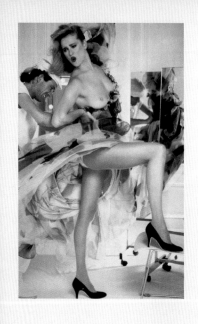

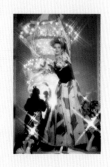

1985 – MARCH

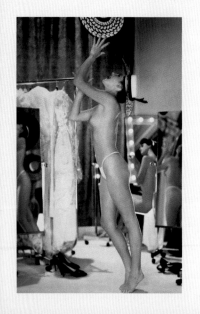

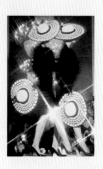

1985 – MAY

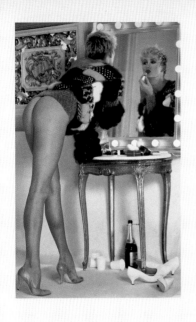

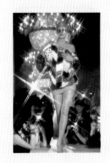

1985 – JUNE

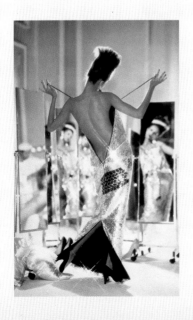

1985 – JULY

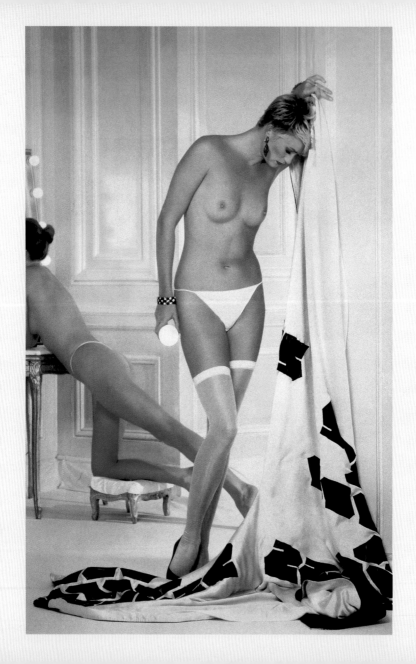

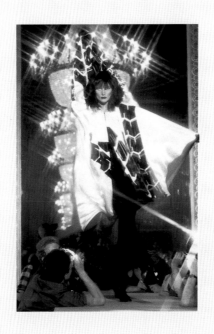

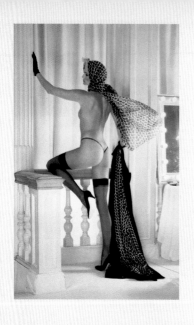

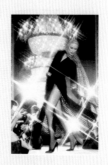

1985 – AUGUST

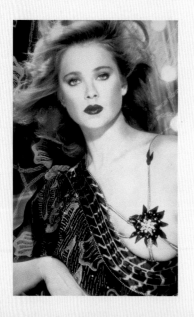

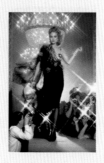

1985 – SEPTEMBER

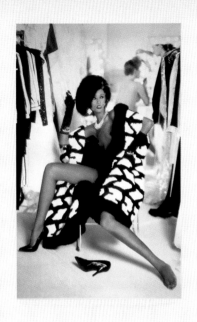

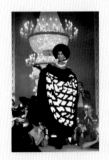

1985 – NOVEMBER

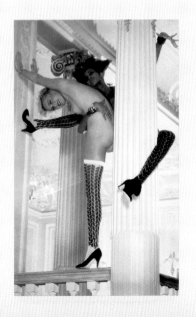

1985 – DECEMBER

1986
Bert Stern

"Removing the Sense of
Guilt From Nudity"—the title
of the June photograph in
the Pirelli calendar—
summarizes the philosophy
of the entire project.
Not that much guilt is still
attached to nudity. If a barrier
of modesty has fallen with
the 1986 calendar, it does not
concern the nudes but the
photographs, which, for
the first time (and without
any sense of guilt), claim
their share of the attention.

ROBERTO DI CARO, *L'ESPRESSO*, NOVEMBER, 24TH, 1985

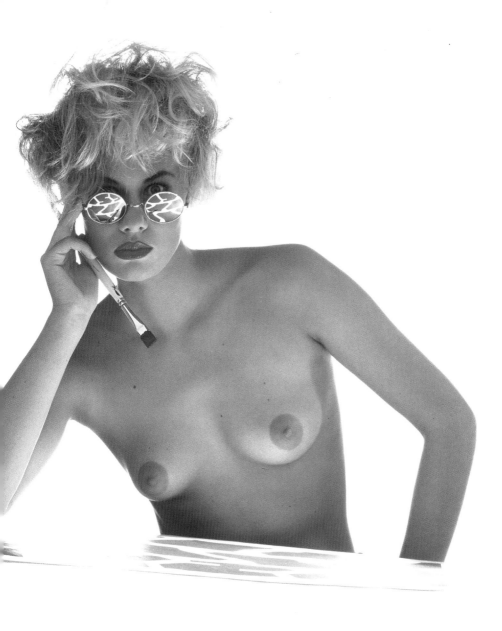

1986 – COVER

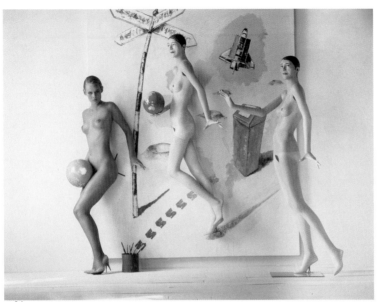

1986 – JANUARY

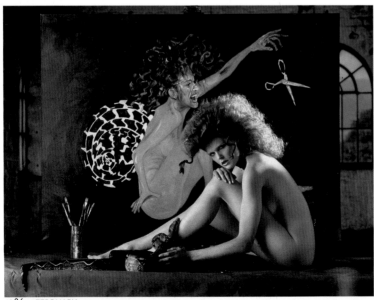

1986 – FEBRUARY

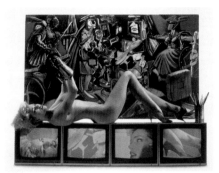

1986 – MARCH

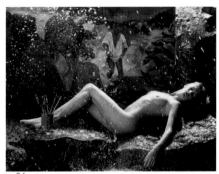

1986 – APRIL

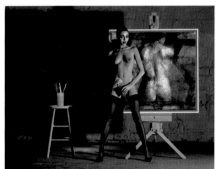

1986 – MAY

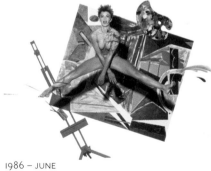

1986 – JUNE

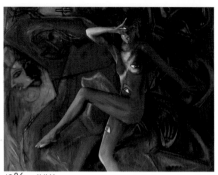

1986 – JULY

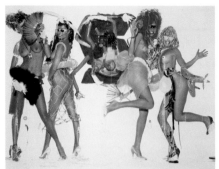

1986 – AUGUST

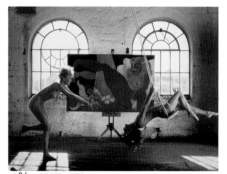

1986 – SEPTEMBER

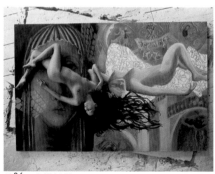

1986 – OCTOBER

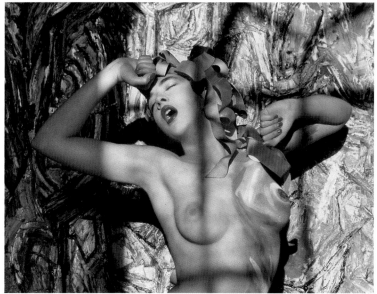

1986 – NOVEMBER

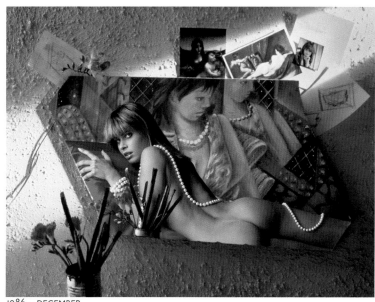

1986 – DECEMBER

1987
Terence Donovan

There is always a moment (which the photographer can summarize and reconstruct almost theatrically), during which a glance, a gesture, an expression, can elicit a reaction, a desire, or a dream.

ITALO ZANNIER, *THE PIRELLI CALENDAR 1964–1998*, 1998

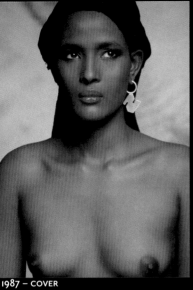

1987 – COVER

1987 – JANUARY

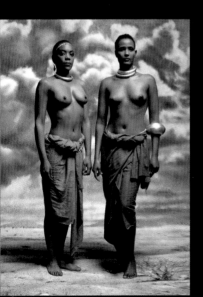

1987 – FEBRUARY

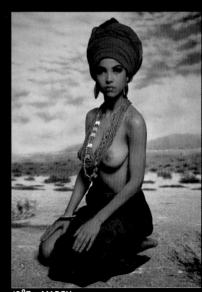

1987 – MARCH

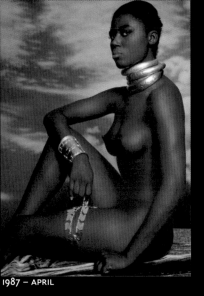

1987 – APRIL

1987 – MAY

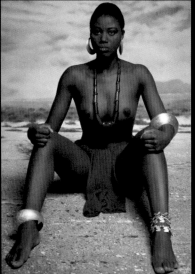

1987 – JUNE

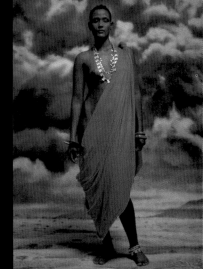

1987 – JULY

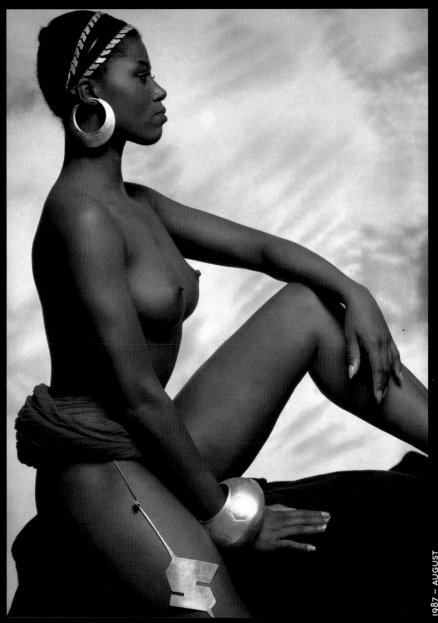

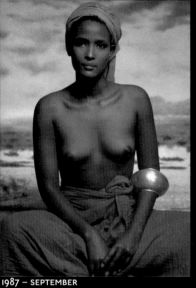

1987 — SEPTEMBER

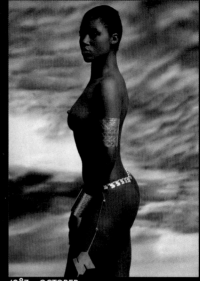

1987 — OCTOBER

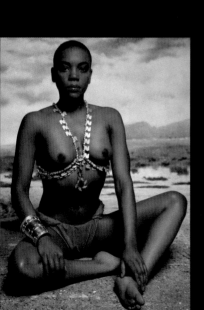

1987 — NOVEMBER

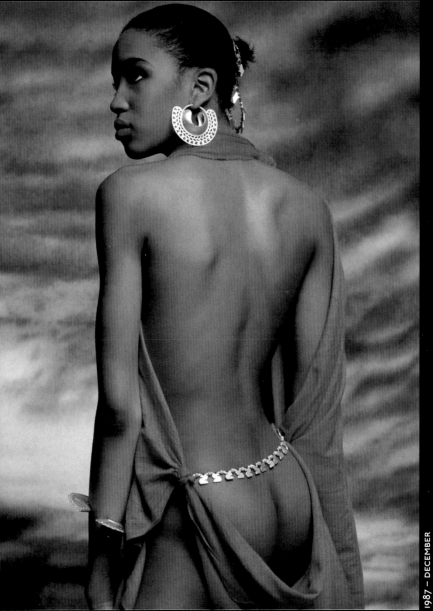

1988
Barry Lategan

All it took to secure the 1988 calendar a place in history was that idea of the man's silhouette, that sort of spiderman with a tiretread stamped on him.

GUIDO VERGANI, *LA REPUBBLICA*, NOVEMBER, 7TH, 1987

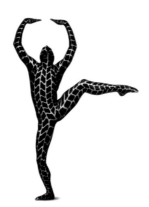

1988 – COVER

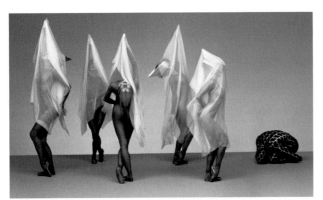

1988 – JANUARY

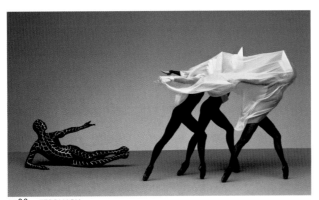

1988 – FEBRUARY

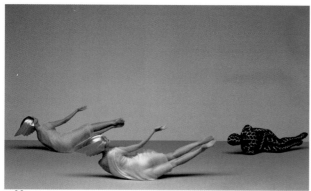

1988 – MARCH

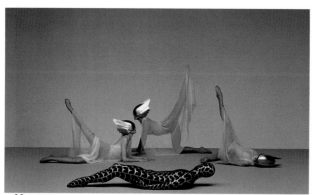

1988 – APRIL

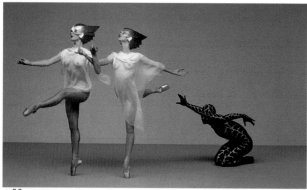

1988 – MAY

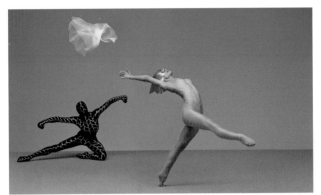

1988 – JUNE

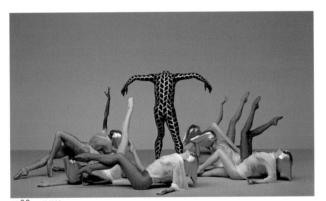

1988 – JULY

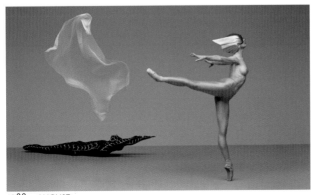

1988 – AUGUST

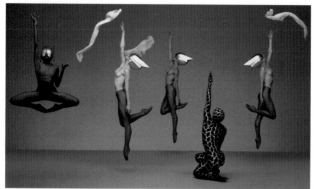

1988 – SEPTEMBER

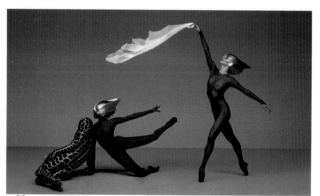

1988 – OCTOBER

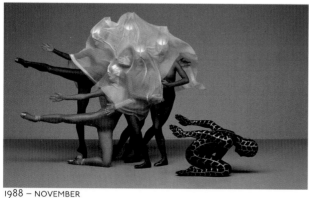

1988 – NOVEMBER

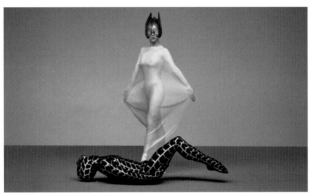

1988 – DECEMBER

1989
Joyce Tenneson

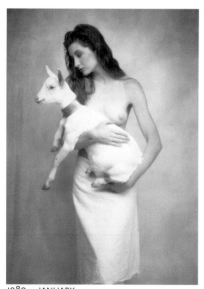

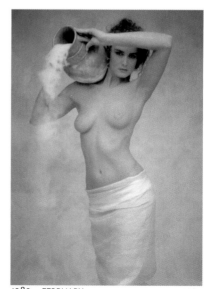

1989 – JANUARY

1989 – FEBRUARY

"I love this camera, and I love the way it manages to reproduce skin tones."

JOYCE TENNESON

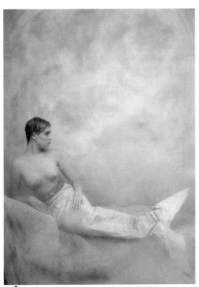

1989 – MARCH

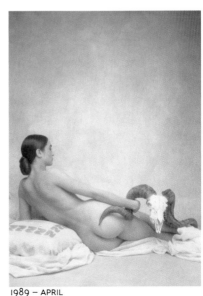

1989 – APRIL

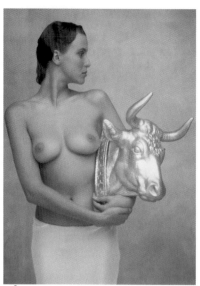

1989 – MAY

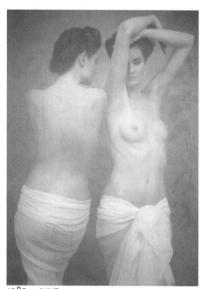

1989 – JUNE

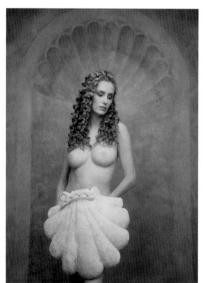

1989 – JULY

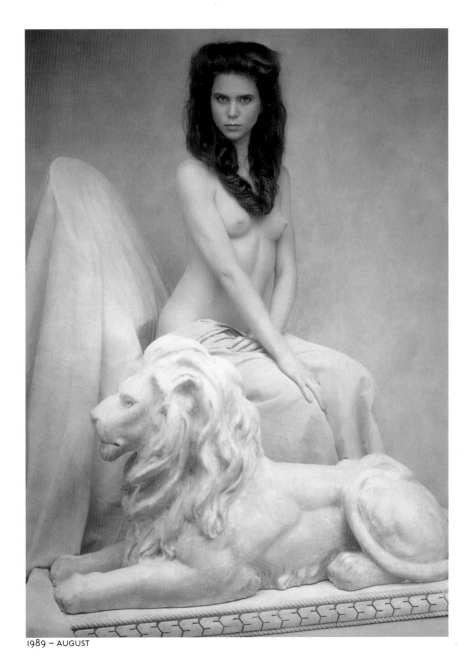

1989 – AUGUST

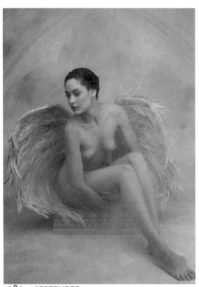

1989 – SEPTEMBER

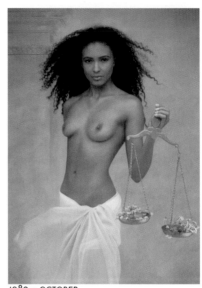

1989 – OCTOBER

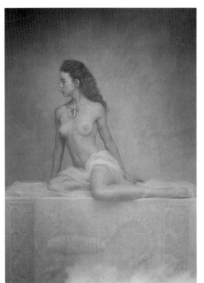

1989 – NOVEMBER

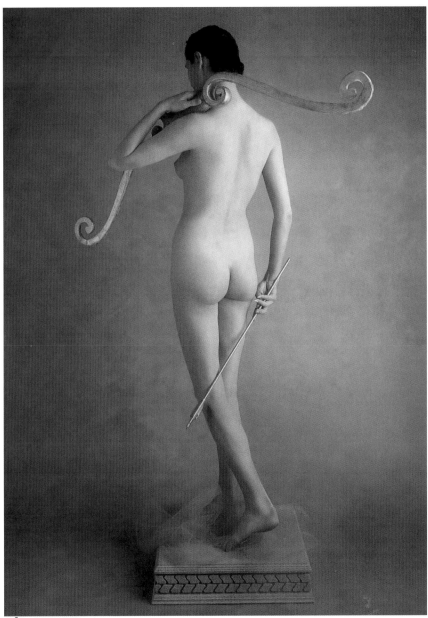

1989 – DECEMBER

1990
Arthur Elgort

When in 1990 Arthur Elgort photographs
women in the style of Leni Riefenstahl,
these pseudo-Olympic athletes must wear
at least a short skirt with the tread marks.

PETER DITTMAR, *DIE WELT*, FEBRUARY, 5TH, 1997

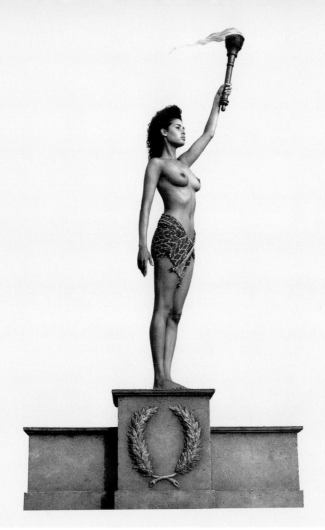

1990 – COVER

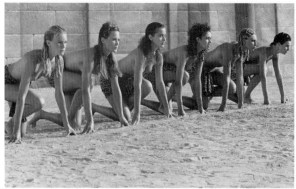

1990 – JANUARY

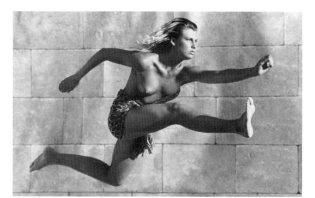

1990 – FEBRUARY

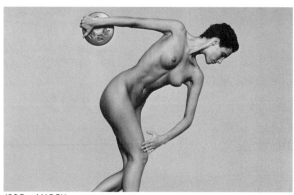

1990 – MARCH

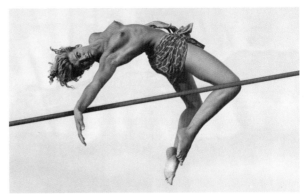

1990 – APRIL

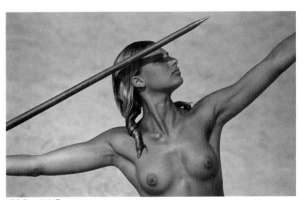

1990 – JUNE

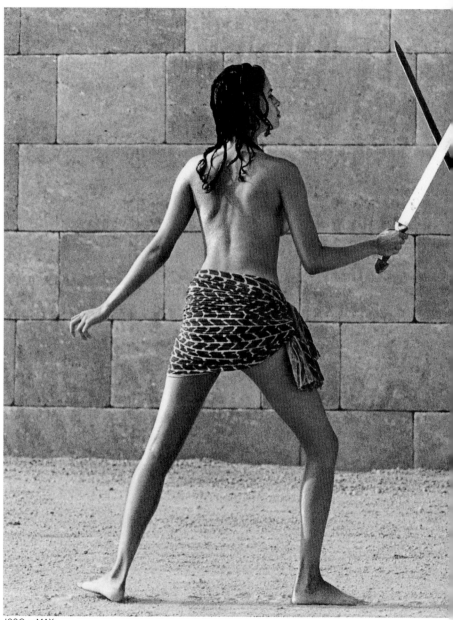

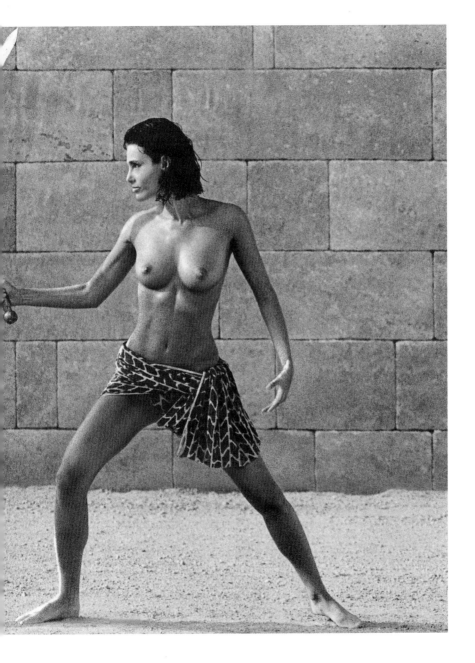

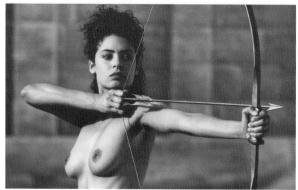

1990 – JULY

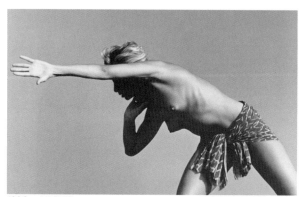

1990 – AUGUST

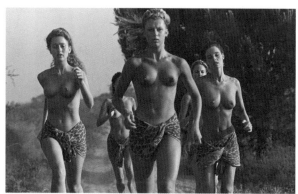

1990 – SEPTEMBER

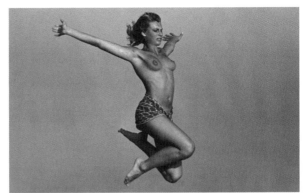

1990 – OCTOBER

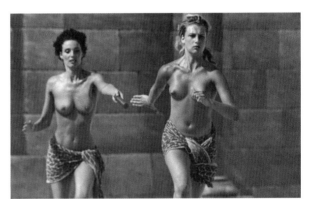

1990 – NOVEMBER

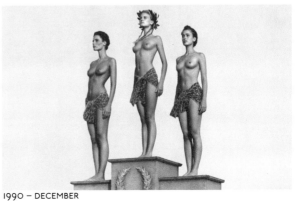

1990 – DECEMBER

1991
Clive Arrowsmith

Undress for history, please

THE EUROPEAN, NOVEMBER, 9ᵀᴴ, 1990

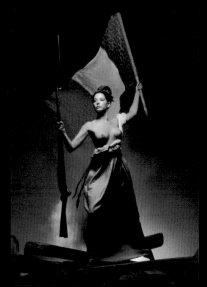

1991 – COVER

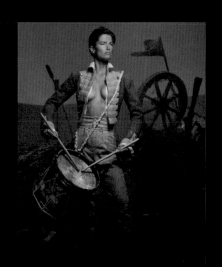

1991 – JANUARY

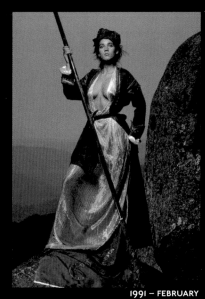

1991 – FEBRUARY

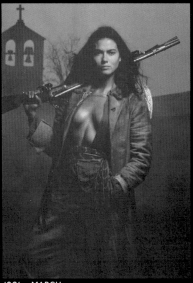

1991 — MARCH

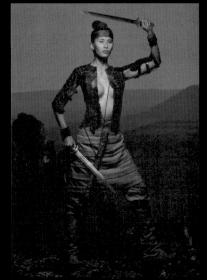

1991 — APRIL

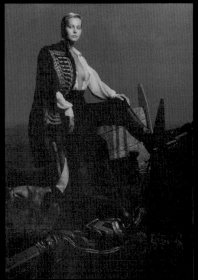

1991 — MAY

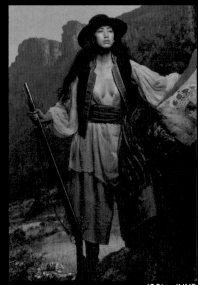

1991 — JUNE

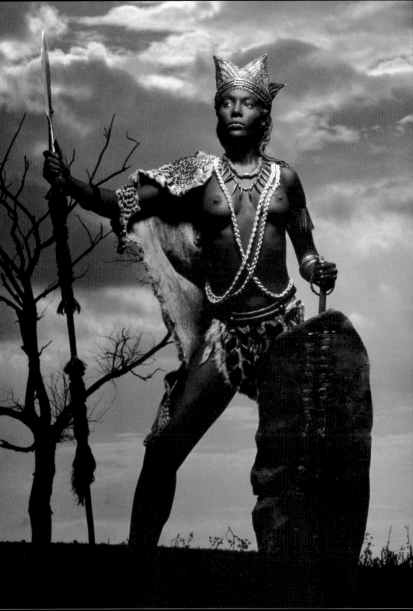

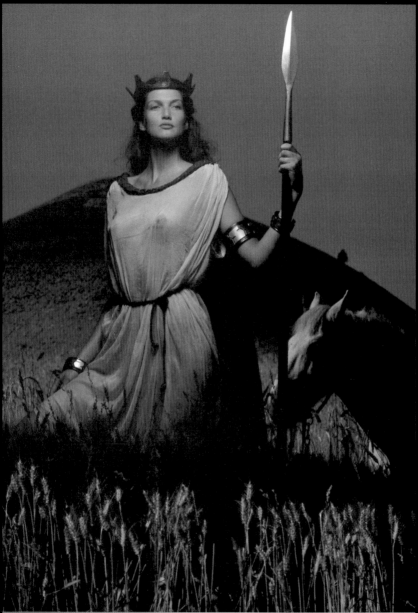

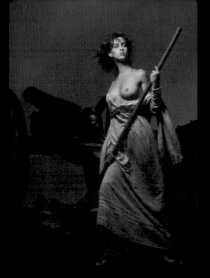

1991 – SEPTEMBER

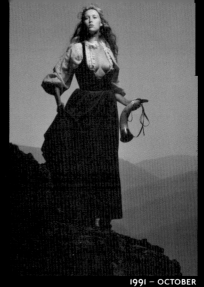

1991 – OCTOBER

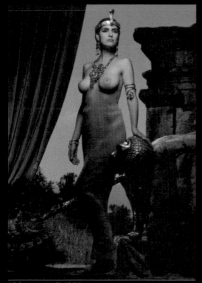

1991 – NOVEMBER

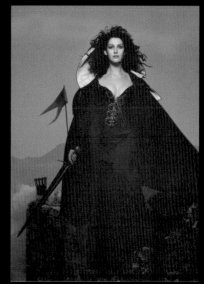

1991 – DECEMBER

1992
Clive Arrowsmith

Dragon-women, monkey-women, tiger-women, horse-women. The Pirelli calendar springs out of an exciting cocktail blending mysterious China with female charm, following English photographer Clive Arrowsmith's idea.

MASSIMO DI FORTI, *IL MESSAGGERO*, NOVEMBER, 12TH, 1991

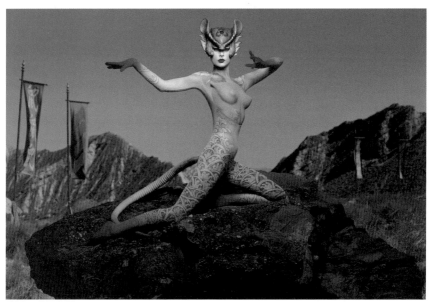

1992 – JANUARY

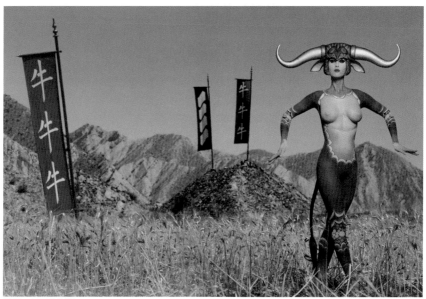

1992 – FEBRUARY

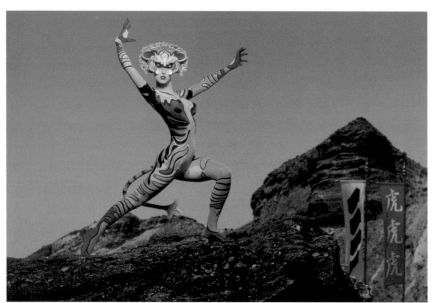

1992 — MARCH

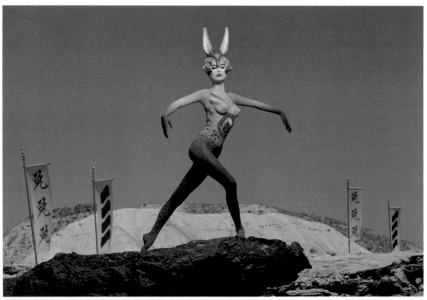

1992 — APRIL

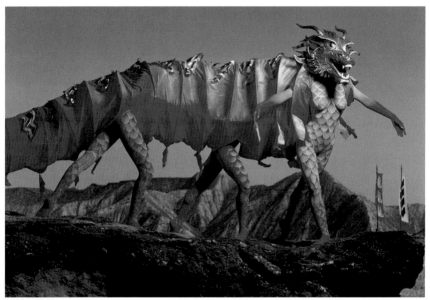

1992 — MAY

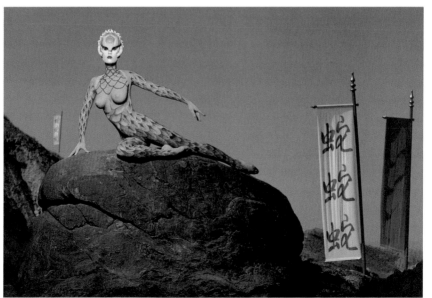

1992 — JUNE

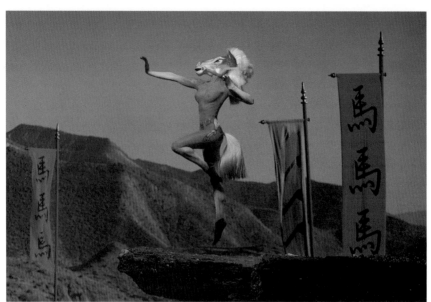

1992 – JULY

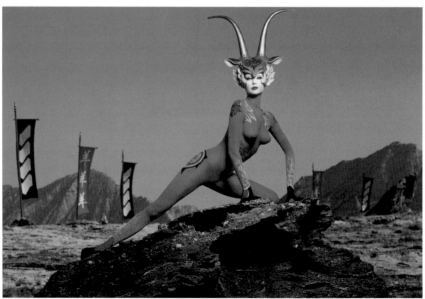

1992 – AUGUST

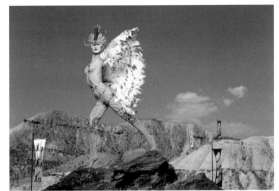

1992 – OCTOBER

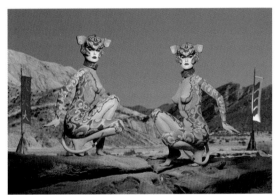

1992 – NOVEMBER

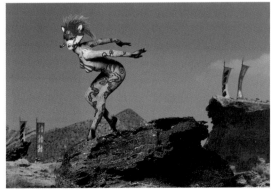

1992 – DECEMBER

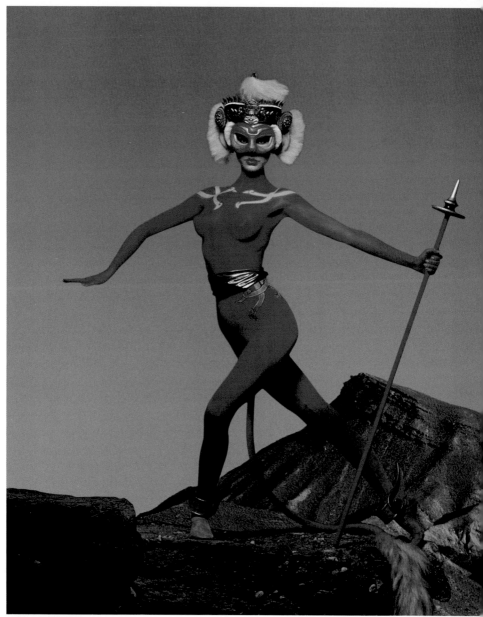

1992 – SEPTEMBER

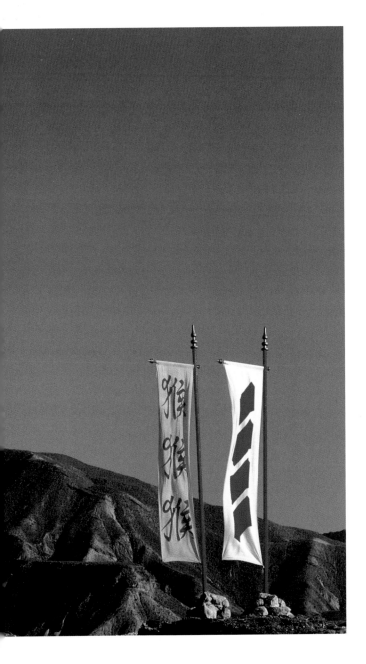

1993
John Claridge

These nudes, with all the pornographic nudity that is available, are almost a return to the Garden of Eden.

GILLO DORFLES, *CORRIERE DELLA SERA*, NOVEMBER, 15TH, 1992

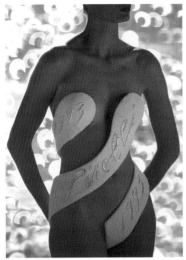

1993 – COVER

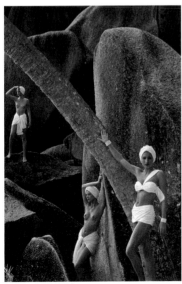

1993 – JANUARY

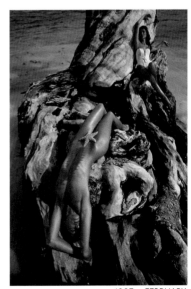

1993 – FEBRUARY

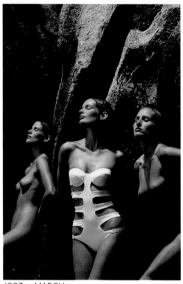

1993 – MARCH

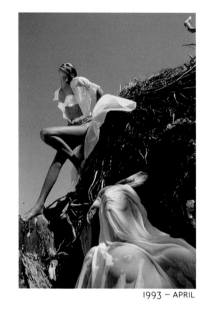

1993 – APRIL

1993 – MAY

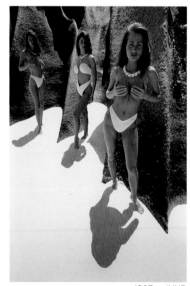

1993 – JUNE

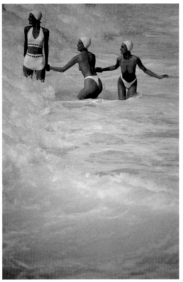

1993 – JULY

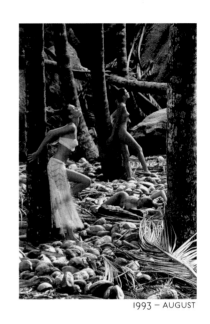

1993 – AUGUST

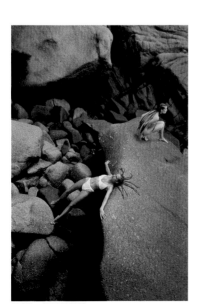

1993 – SEPTEMBER

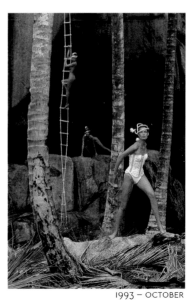

1993 – OCTOBER

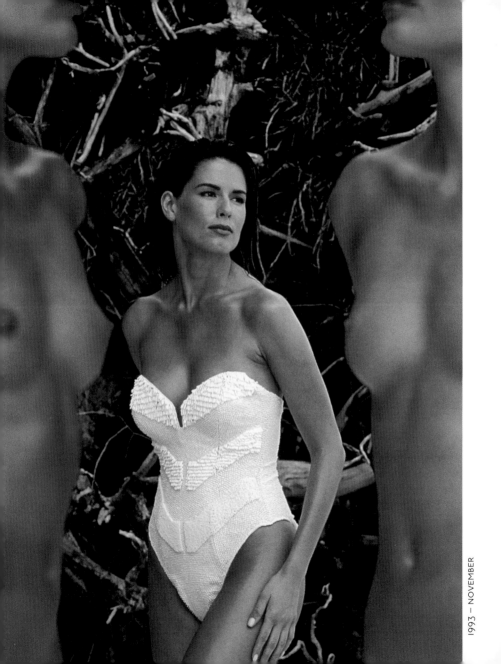

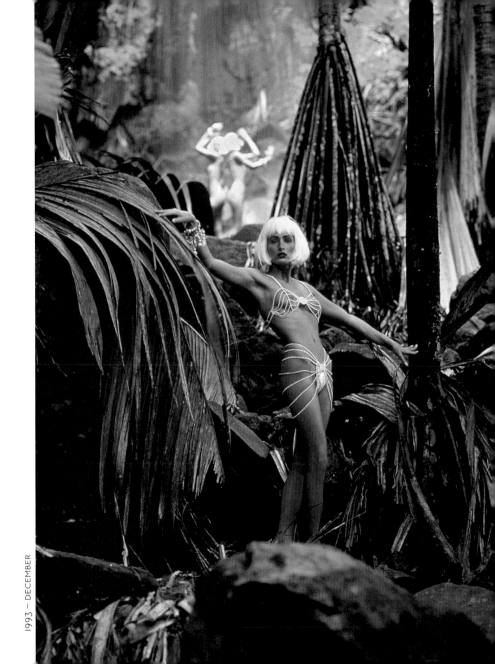

1994
Herb Ritts

Four of the world's top supermodels,
the photographer behind Michael Jackson's videos, Madonna's fashion stylist, Kim Basinger's make-up artist, Michelle Pfeiffer's hairdresser... on a deserted beach in the Bahamas.

SUE WILLIAMS, *THE WEEKLY*, NOVEMBER, 25TH, 1993

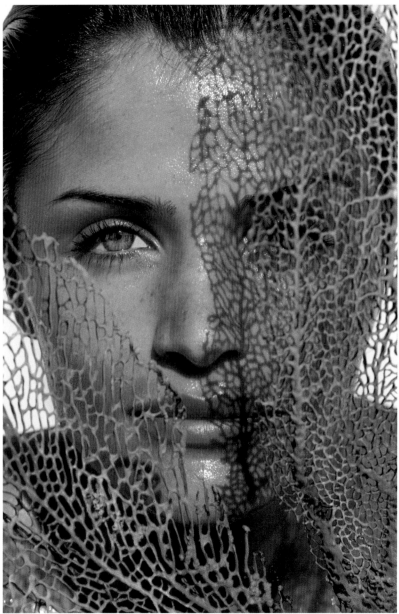

1994 – COVER

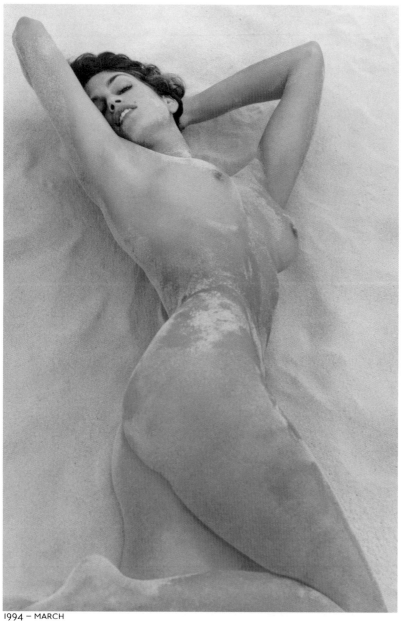

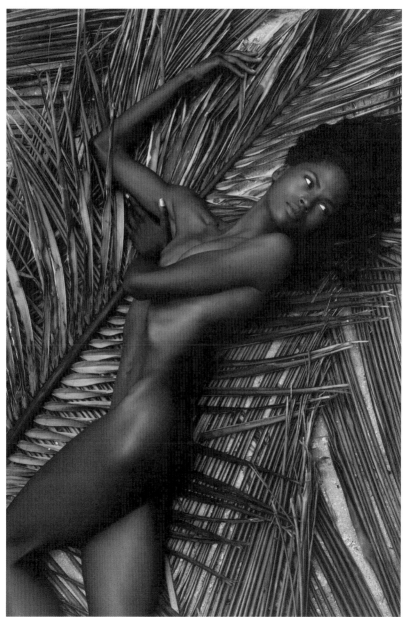

1994 – AUGUST

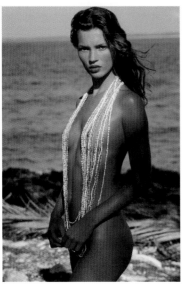

1994 – JANUARY

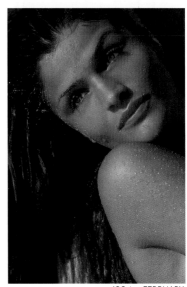

1994 – FEBRUARY

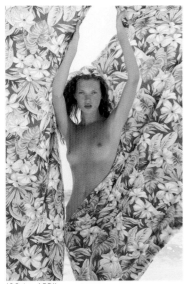

1994 – APRIL

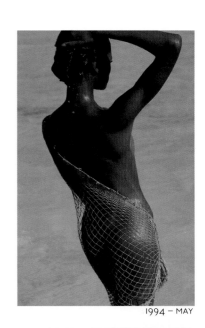

1994 – MAY

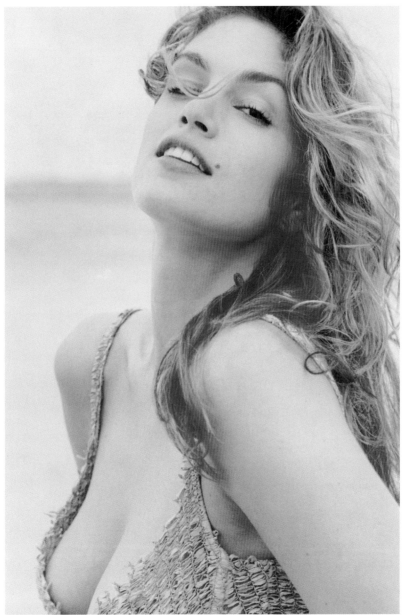

1994 – JUNE

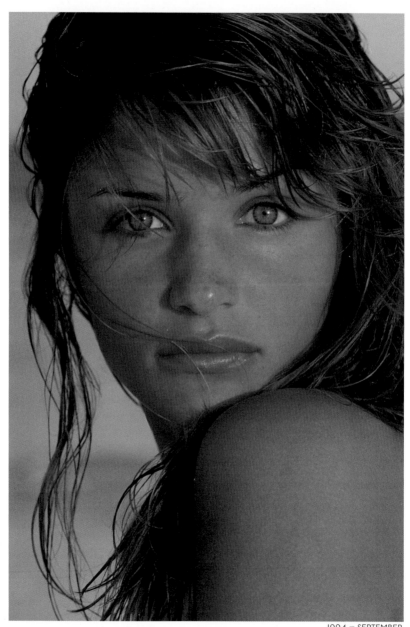

1994 – SEPTEMBER

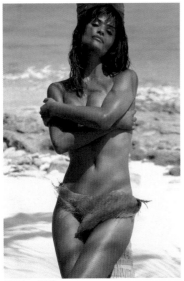

1994 – JULY

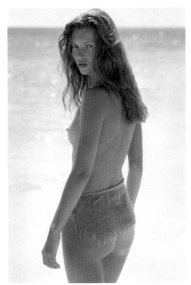

1994 – OCTOBER

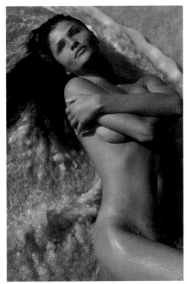

1994 – NOVEMBER

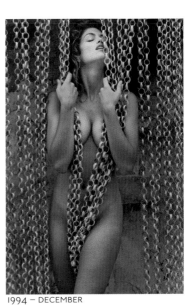

1994 – DECEMBER

1995
Richard Avedon

Richard Avedon 1995 calendar is the real classic, full of fantasy and a vivid reminder that, before he became quite so grand as he now is, he was the very best fashion photographer going.

JOHN RUSSELL TAYLOR, *THE TIMES*, FEBRUARY, 7TH, 1997

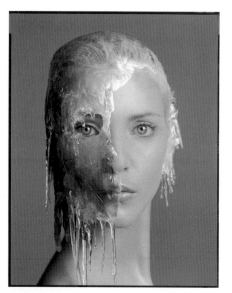

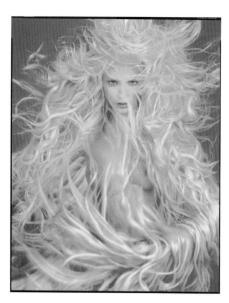

1995 – JANUARY

1995 – FEBRUARY

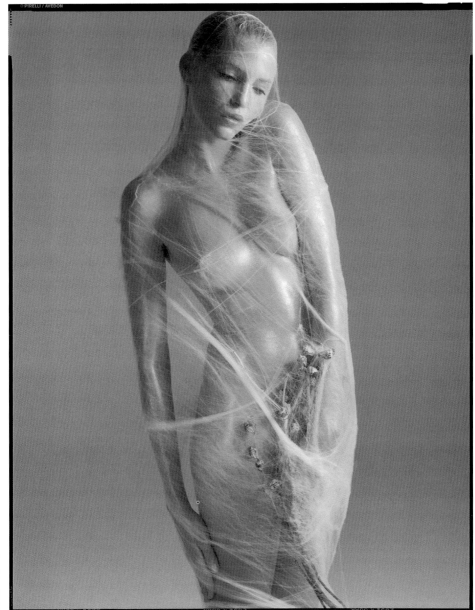

1995 — MARCH

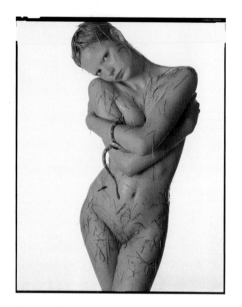

1995 – APRIL

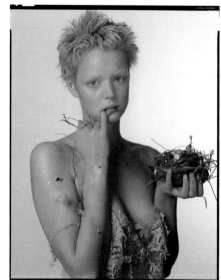

1995 – MAY

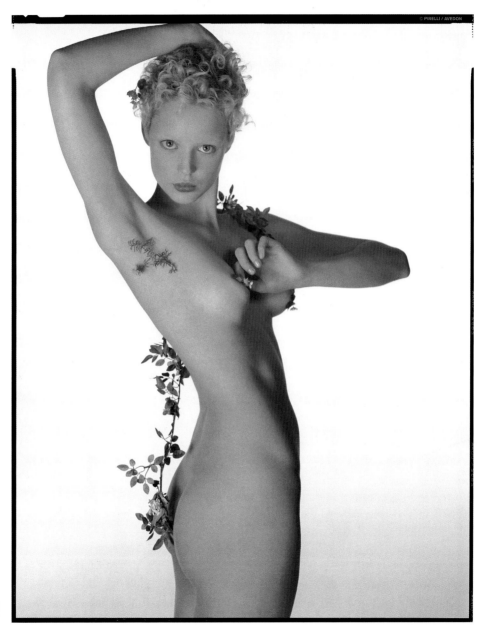

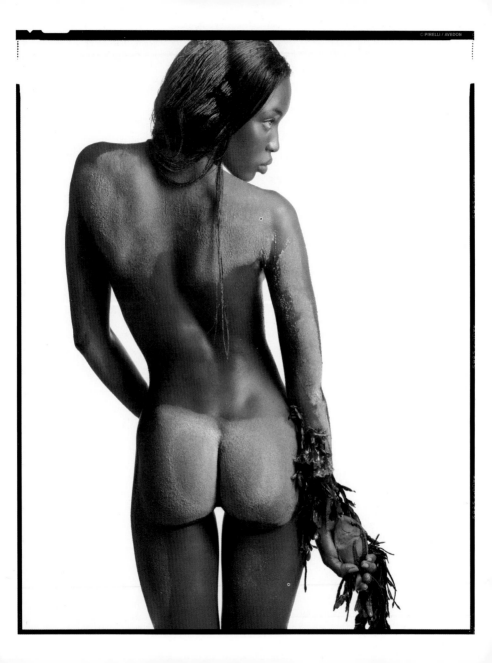

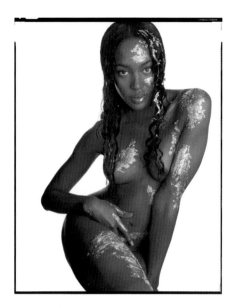

1995 – AUGUST

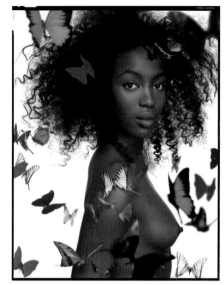

1995 – SEPTEMBER

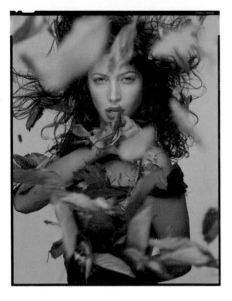

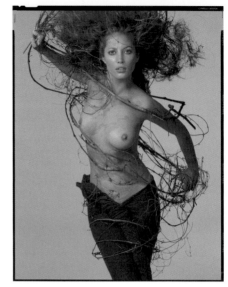

1995 – OCTOBER 1995 – NOVEMBER

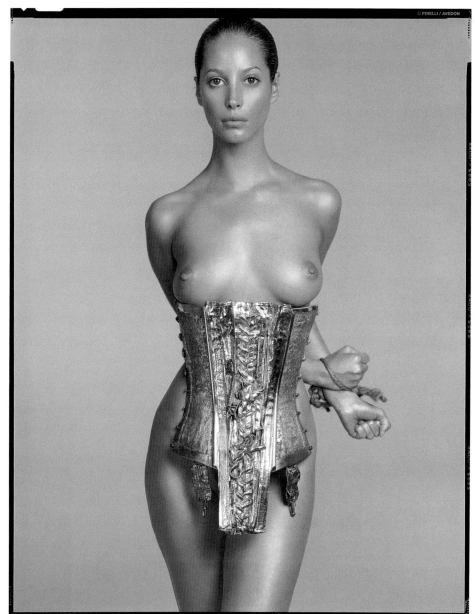

1996
Peter Lindbergh

"Nothing is sexier than personality. The woman that has the courage to be herself is automatically sexy, even without high heels and a miniskirt."

PETER LINDBERGH

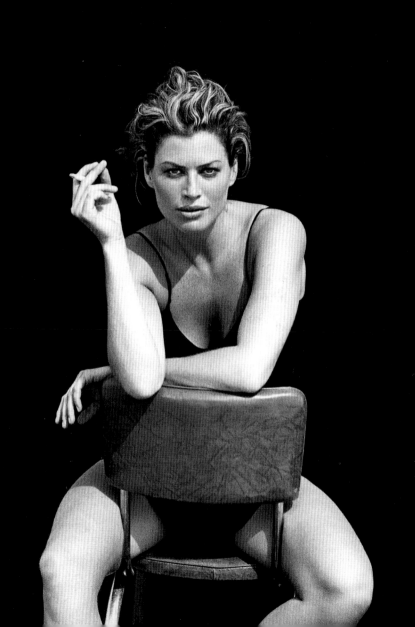

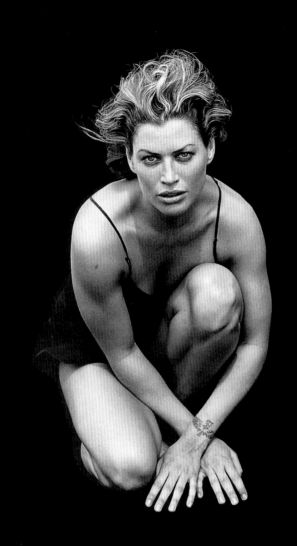

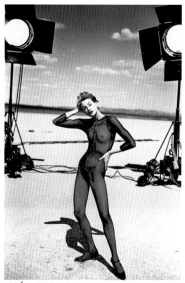

1996 – FEBRUARY

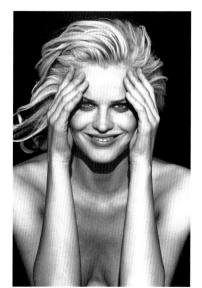

1996 – MARCH

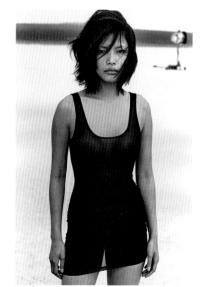

1996 – APRIL

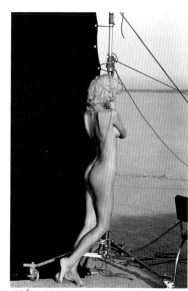

1996 – JUNE

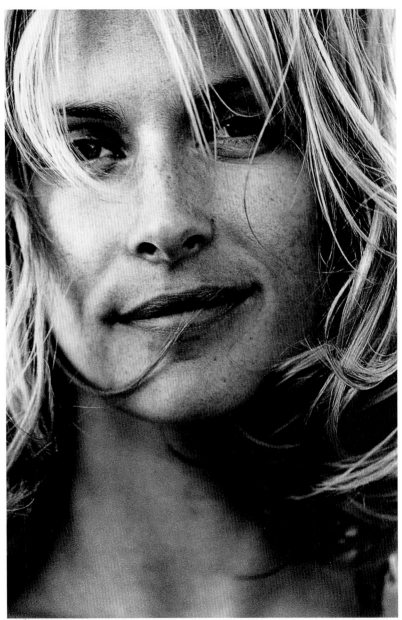

1996 — MAY

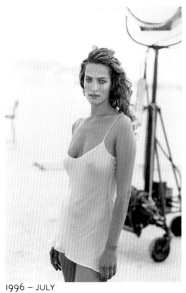

1996 – JULY

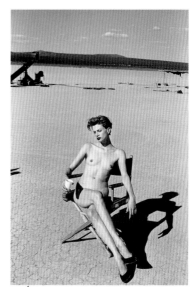

1996 – AUGUST

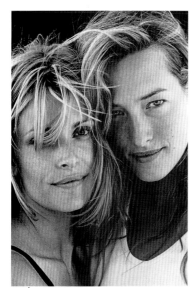

1996 – SEPTEMBER

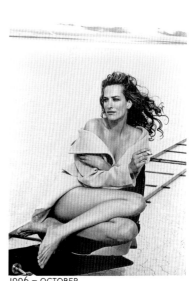

1996 – OCTOBER

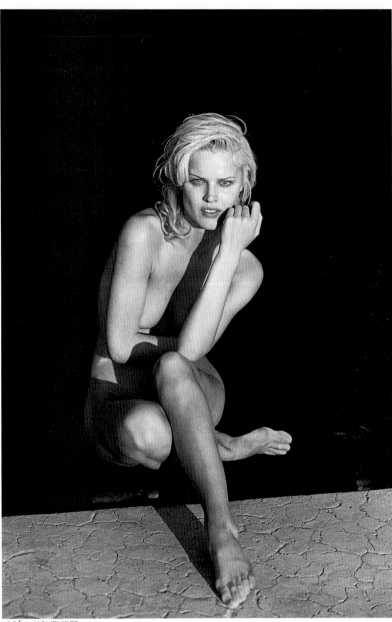

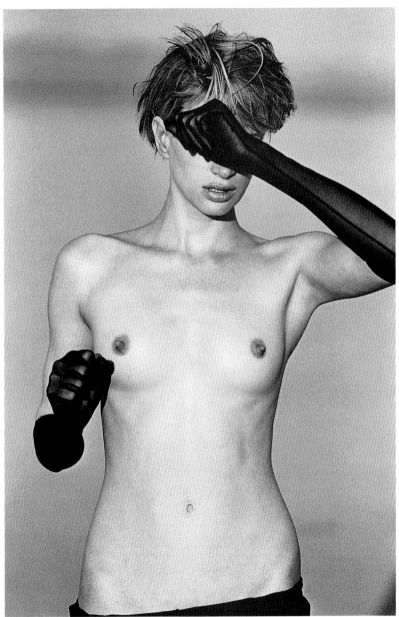

1996 – DECEMBER

1997
Richard Avedon

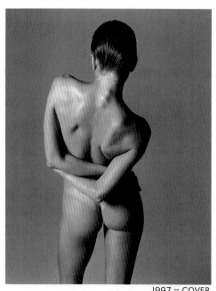

If the original calendar was a product of 1960s notions of liberated sexuality, its current incarnation is in step with the multiculturalism of the '90s.

CAROL SQUIERS, *PHOTO*, MARCH–APRIL 1997

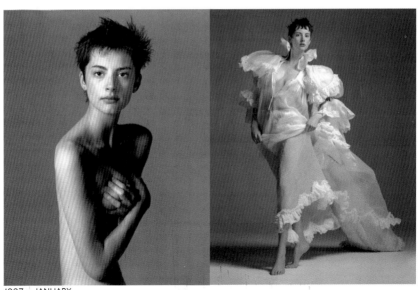

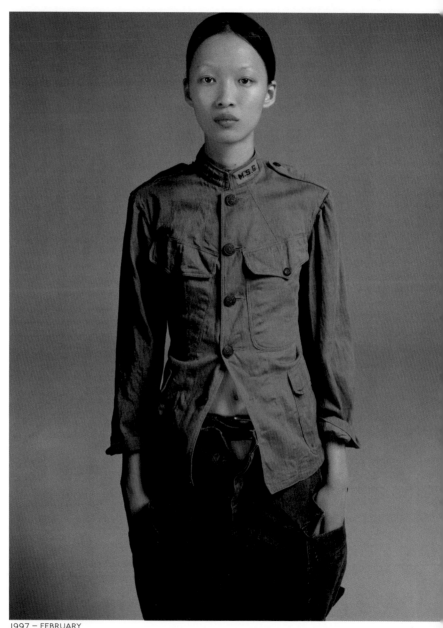

1997 – FEBRUARY

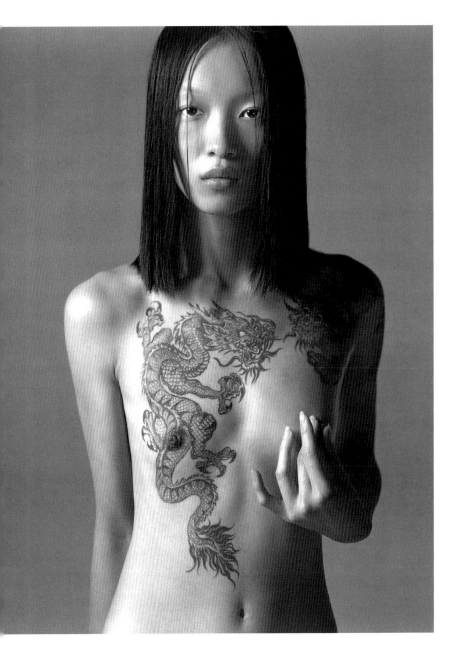

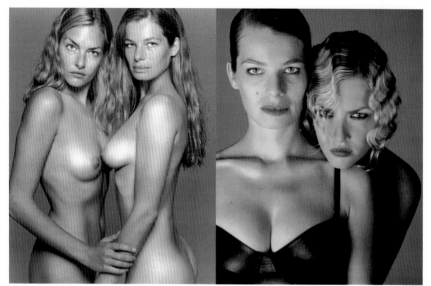

1997 – MARCH

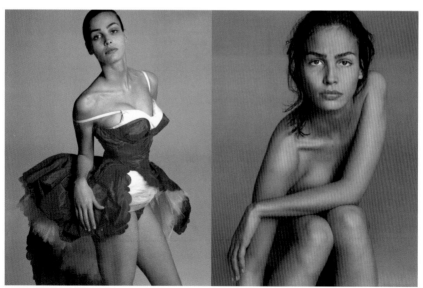

1997 – APRIL

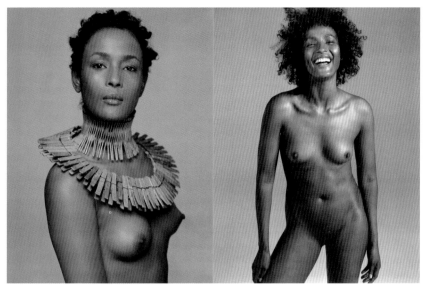

1997 – MAY

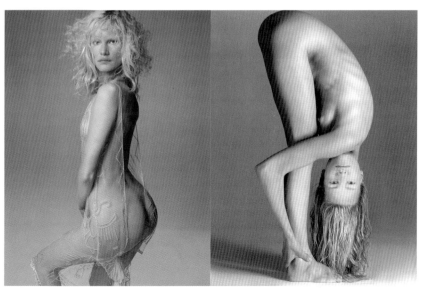

1997 – JUNE

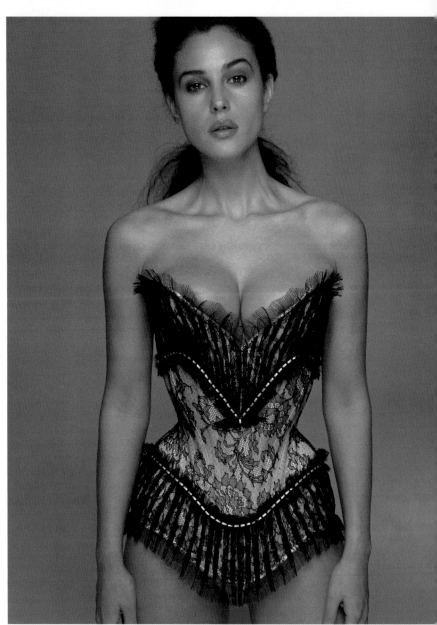

1997 — JULY

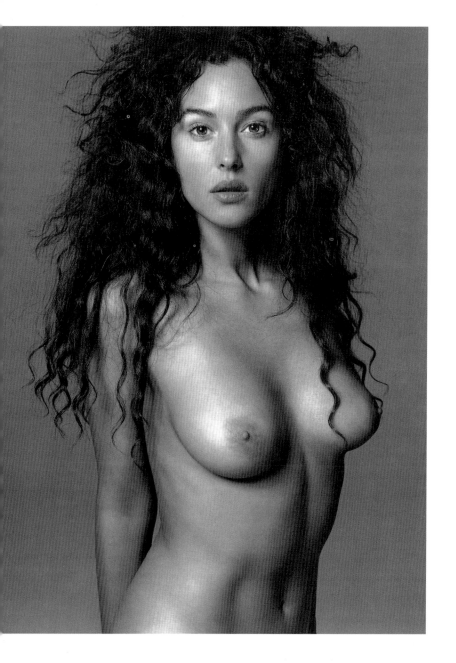

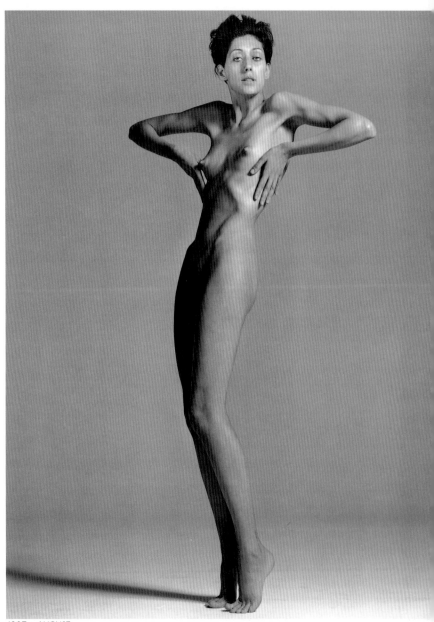

1997 – AUGUST

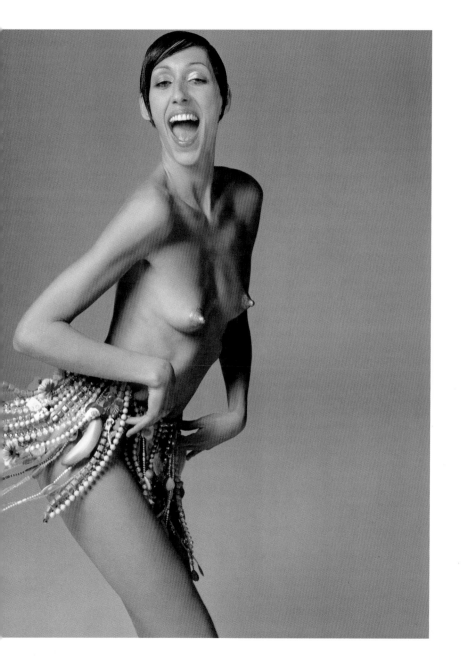

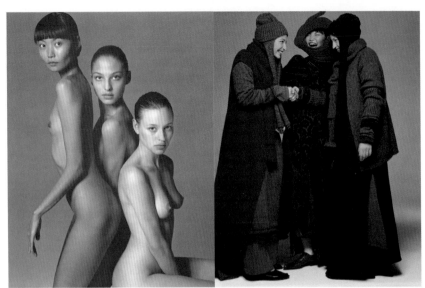

1997 – SEPTEMBER

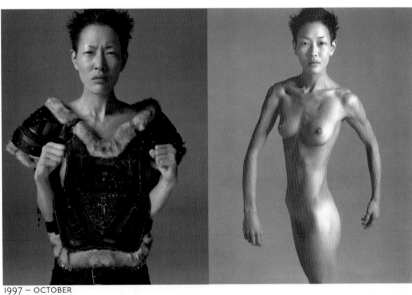

1997 – OCTOBER

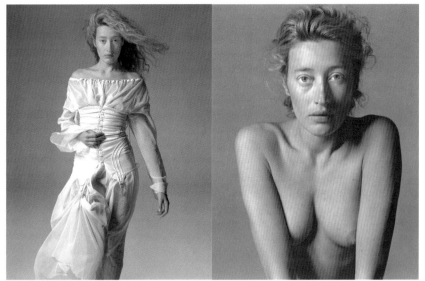

1997 – NOVEMBER

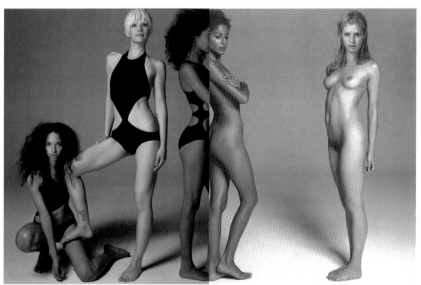

1997 – DECEMBER

1998
Bruce Weber

For the 25th-anniversary edition, Weber broke with tradition and included photos of famous (clad) men alongside the usual drop-dead (not so clad) babes. His title: "Women that men live for, Men that women live for."

SUE ZESIGER, *FORTUNE*, JANUARY, 16TH, 1998

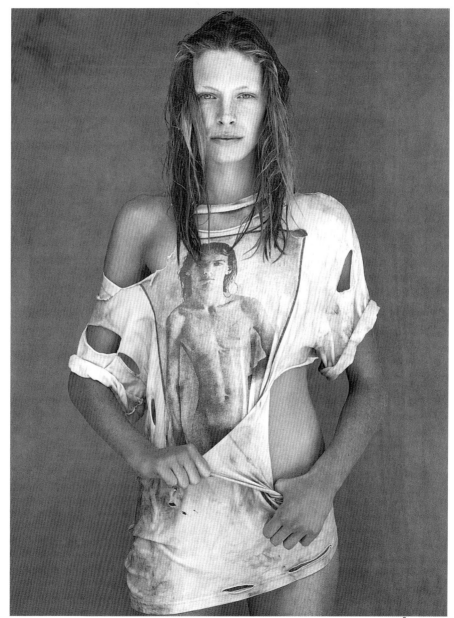

1998 – COVER

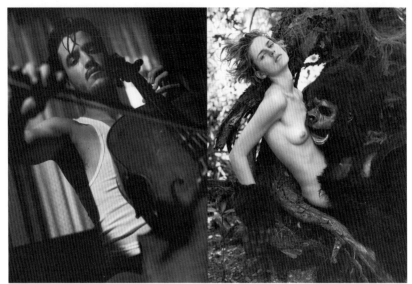

1998 – JANUARY

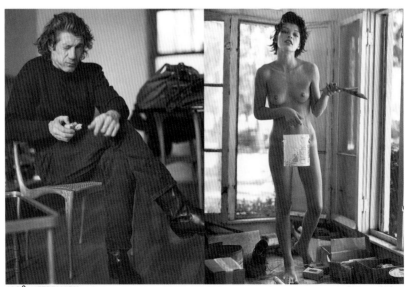

1998 – FEBRUARY

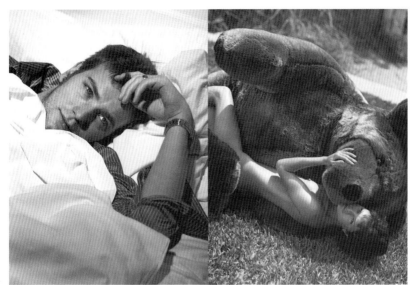

1998 – MARCH

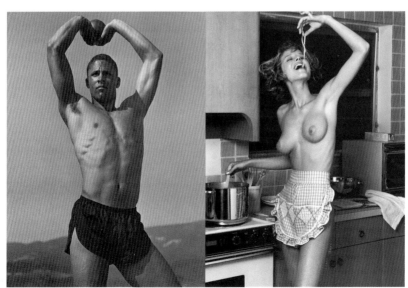

1998 – APRIL

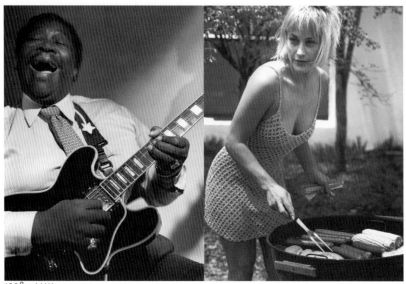

1998 — MAY

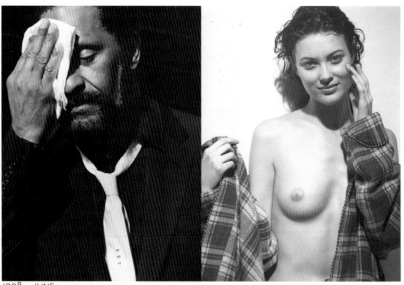

1998 — JUNE

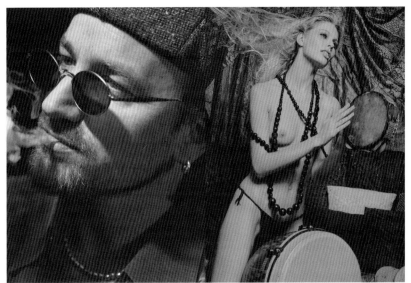

1998 – JULY

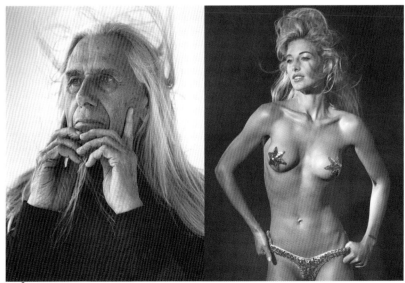

1998 – AUGUST

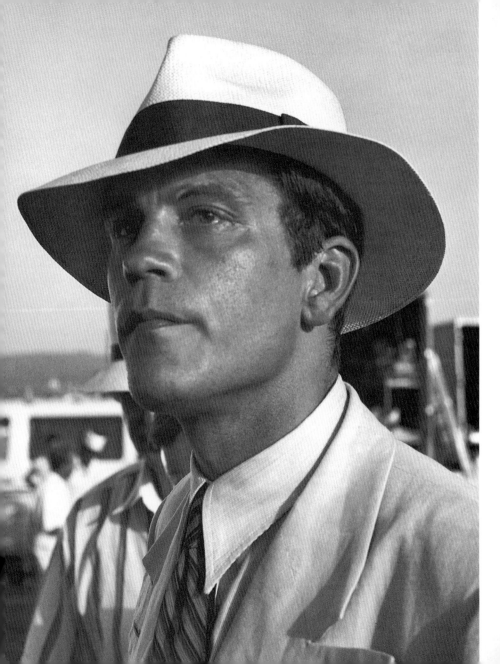

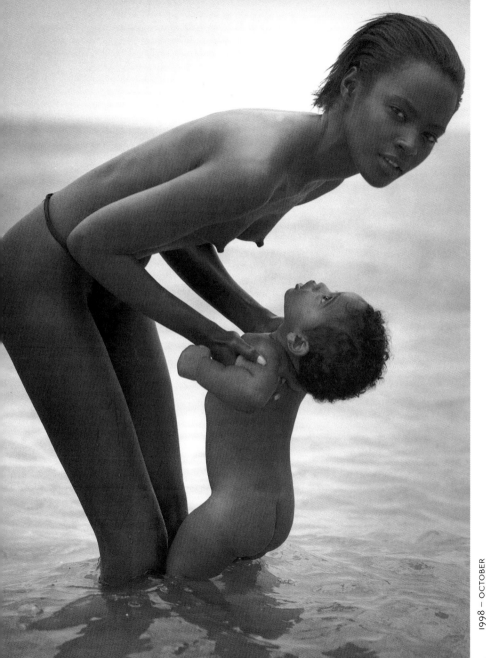

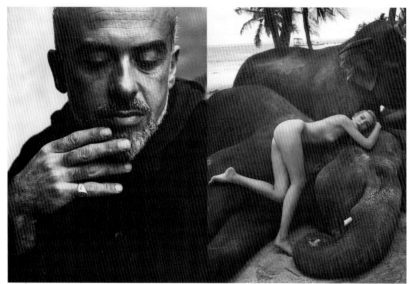

1998 – SEPTEMBER

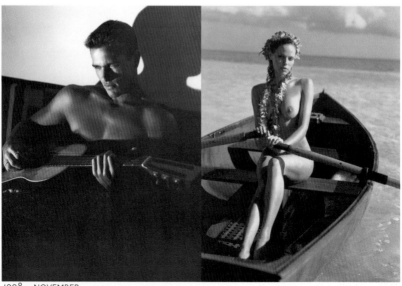

1998 – NOVEMBER

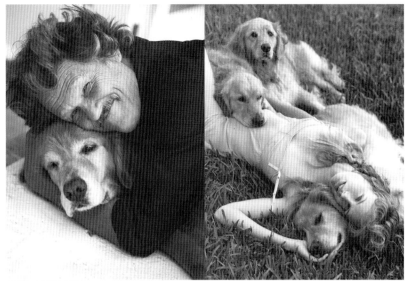

1998 – DECEMBER

1998 – COVER

1999
Herb Ritts

London gets its new Pirelli every November... at the same time that Paris gets its Beaujolais... The 1999 calendar by Herb Ritts is a retrospective of all the great female myths of the 1900s.

SOPHIE CARQUAIN, *LE FIGARO*, NOVEMBER, 23RD, 1998

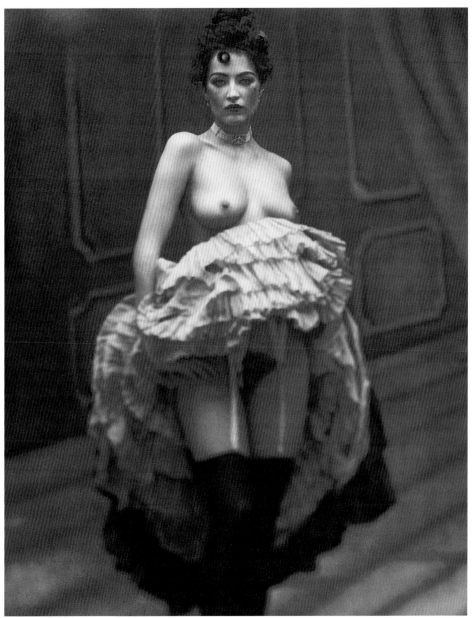

1999 – JANUARY

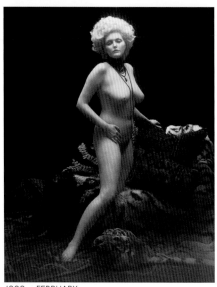

1999 – FEBRUARY

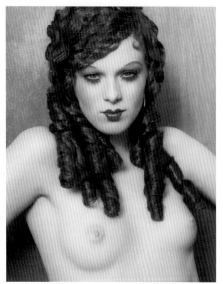

1999 – MARCH

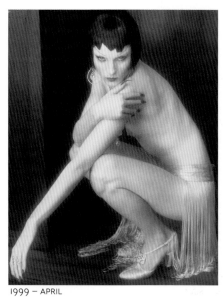

1999 – APRIL

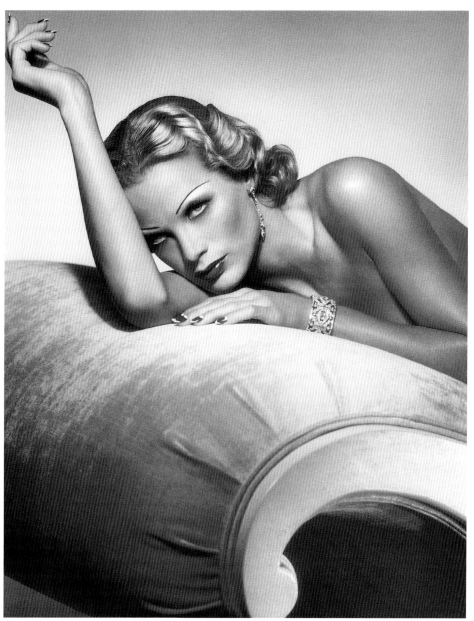

1999 – MAY

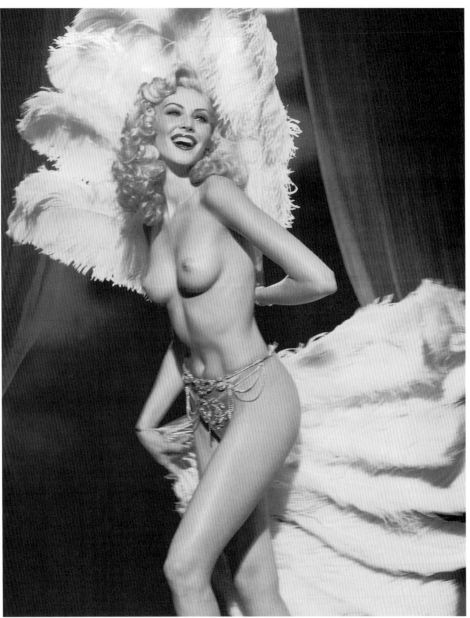

1999 — JUNE

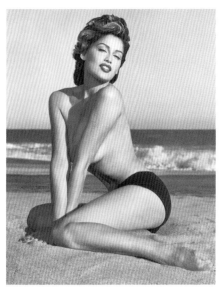

1999 – JULY

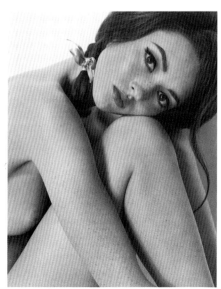

1999 – AUGUST

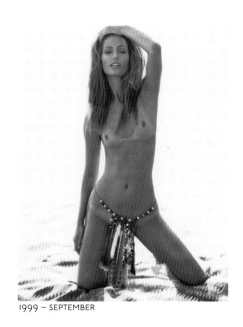

1999 – SEPTEMBER

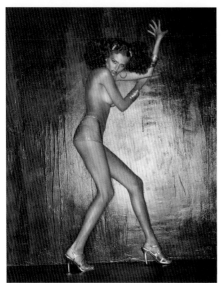

1999 – OCTOBER

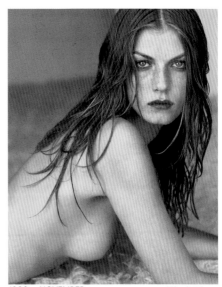

1999 – NOVEMBER

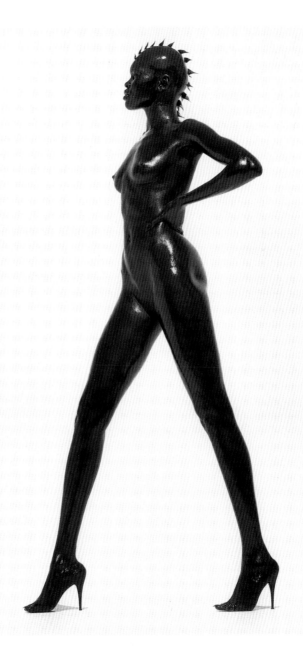

2000
Annie Leibovitz

"I am a big admirer of very
classic work. When Pirelli
asked me to do the calendar,
it was an opportunity for me
to work out this exercise of
looking at women in a very
classic way. This is really
like joining a club... a very
exclusive club. I was also
very excited about the idea
of being a woman and being
asked to do the Pirelli
Calendar."

ANNIE LEIBOVITZ

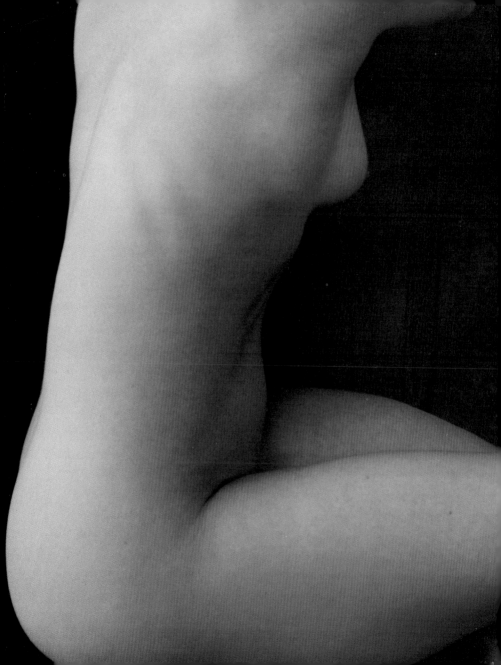

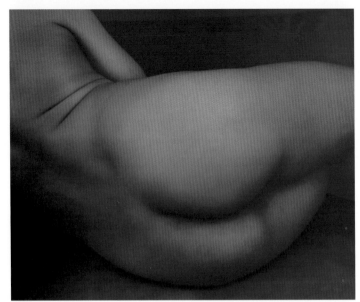

2000 — FEBRUARY

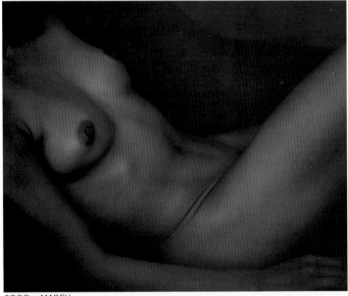

2000 — MARCH

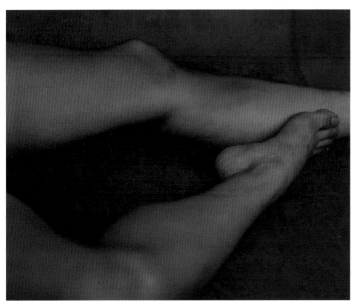

2000 – APRIL

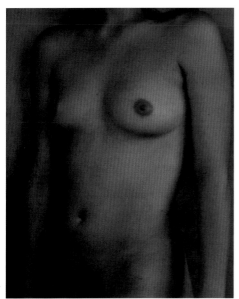

2000 – MAY

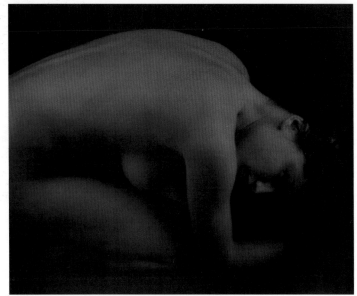

2000 – JUNE

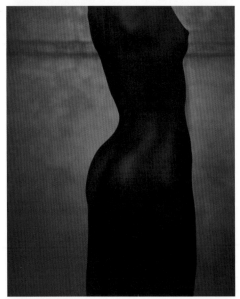

2000 – JULY

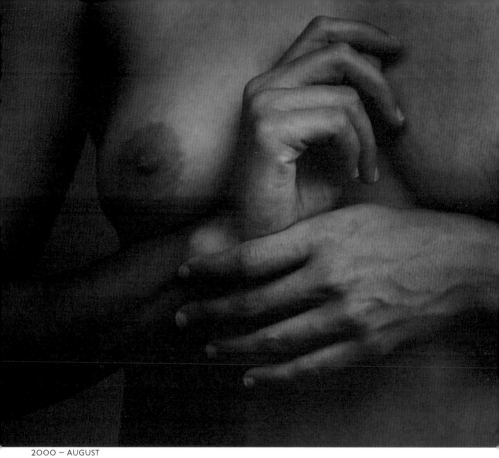

2000 – AUGUST

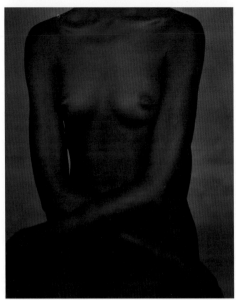

2000 – SEPTEMBER

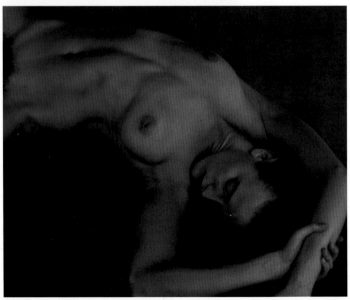

2000 – OCTOBER

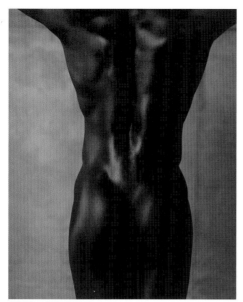

2000 — NOVEMBER

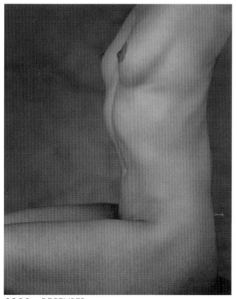

2000 — DECEMBER